Port Colborne Ontario Book 2 in Colour Photos, Saving Our History One Photo at a Time

Photography
by Barbara Raué
2017

Series Name:
Cruising Ontario

Book 168: Port Colborne Book 2

Cover photo: 214 Steele Street, Steele Street Public School, Page 57

Barbara is The Authority on Saving Our History One Photo at a Time.

Photos are now in full color.

Books Available in Alphabetical Order: Aberfoyle, Acton, Alton, Amherstburg, Ancaster, Arthur, Aylmer, Ayr, Bloomingdale, Brantford, Burlington, Caledon, Caledonia, Cambridge, Clifford, Conestogo, Delhi, Dorchester to Aylmer, Drayton, Drumbo, Dundas, Eden Mills, Elmira, Elora, Essex, Fergus, Guelph, Hagersville, Hamilton, Hanover, Harriston, Hespeler, Jarvis, Kingston, Kingsville, Kitchener, Linwood, Listowel, London, Lucknow, Mono, Mount Forest, Neustadt, New Hamburg, Niagara-on-the-Lake, Oakville, Orangeville, Orillia, Owen Sound, Palmerston, Peterborough, Petrolia, Port Elgin, Preston, Rockwood, Sarnia, Seaforth, Sheffield, Shelburne, Simcoe, Southampton, St. Jacobs, St. Marys, St. Thomas, Stoney Creek, Stratford, Thamesford, Tillsonburg, Waterdown, Waterford, Waterloo, Welland, Wellesley, Windsor, Wingham, Woodstock

Book 125-127: Woodstock
Book 128: Thamesford
Book 129-132: St. Marys
Book 133-136: Sarnia
Book 137: Petrolia
Book 138-139: Welland
Book 140-145: Kingston
Book 146-149: Ottawa
Book 150-151: Midland
Book 152: Penetanguishene
Book 153: Kemptville
Book 154: Cornwall
Book 155: Mariatown to Maitland
Book 156: Morrisburg
Book 157: Brockville
Book 158: Merrickville
Book 159: Smiths Falls
Book 160: Portland, Newboro
Book 161: Westport & Area
Book 162: Perth
Book 163-166: Belleville
Book 167-168: Port Colborne
Book 169: Erin in Colour
Book 170: Goderich in Colour
Book 171: Sault Ste. Marie

Other Books by Barbara Raue

Coins of Gold

Arrows, Indians and Love

The Life and Times of Barbara
Volume 1: Inventions That Have Enhanced My Life
Volume 2: Entertainment That I Have Enjoyed
Volume 3: East Coast Trips
Volume 4: Olympics Have Always Intrigued Me
Volume 5: Wonders of the World
Volume 6: Caribbean Cruises We Have Enjoyed
Volume 7: Animals
Volume 8: Storms and Other Major Disasters in My Lifetime
Volume 9: Wars, Terrorist Attacks and Major Disasters

The Cromwell Family Book

Laura Secord Discovered

Daddy Where Are You?

Montana Series
Book 1: Montana Dream
Book 2: Life on the Montana Frontier
Book 3: Montana to Boston and Back
Book 4: Montana Sons Go to War
Book 5: Montana Sons Return From War

Visit Barbara's website to view all of her books
http://barbararaue.ca

Table of Contents

Main Street West	Page 6
Welland Canal	Page 19
Firelane No. 1	Page 26
Davis Street	Page 29
Sherk Road	Page 31
Lake Street	Page 33
Sugarloaf Street	Page 34
Tennessee Avenue	Page 45
Steele Street	Page 53
Sherwood Forest Lane	Page 62
Architectural Terms	Page 62
Building Styles	Page 66

Port Colborne is a city on Lake Erie, at the southern end of the Welland Canal. Port Colborne was one of the hardest hit communities during the blizzard of 1977. Thousands of people were stranded when the city was paralyzed during the storm.

During the 1880s, American tourists from the southern states began building vacation homes on the lakeshore of the western edge of the town. Before long, an entire gated community of vacationers from the south called Port Colborne their home during the summer months. Today, the picturesque street of Tennessee Avenue is still home to many of these original vacation homes and buildings, as well as the original stone and wrought iron resort gates. The street boasts some immaculately maintained examples of late 19th and early 20th century Southern architecture.

The International Nickel Company (now Vale) has been one of the city's main employers since the opening of a refinery in 1918. Taking advantage of inexpensive hydroelectricity from generating stations at nearby Niagara Falls, the refinery produced electro-refined nickel for the war effort, and continues in operation today.

The Welland Canal was originally established as a solution to summer water shortages that plagued a grist mill operation near St. Catharines. William Hamilton Merritt, the mill owner, diverted water from the Welland River into Twelve Mile Creek. He wanted to make the channel deep enough to allow boats to pass through a series of locks down the escarpment into Twelve Mile Creek and on to Lake Ontario.

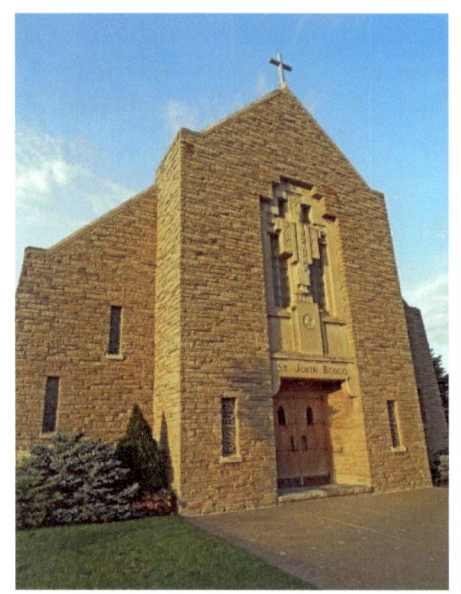 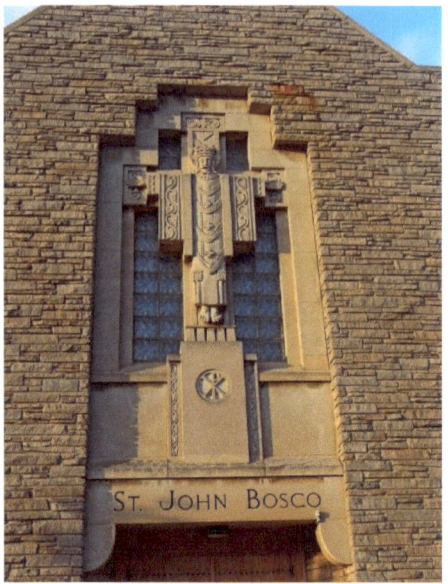

375 Main Street West – St. John Bosco Catholic Church

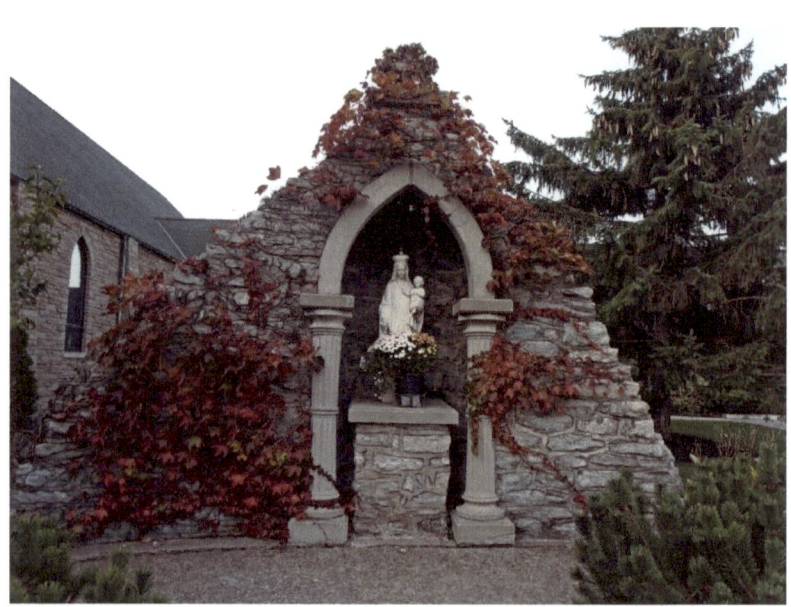

Grotto

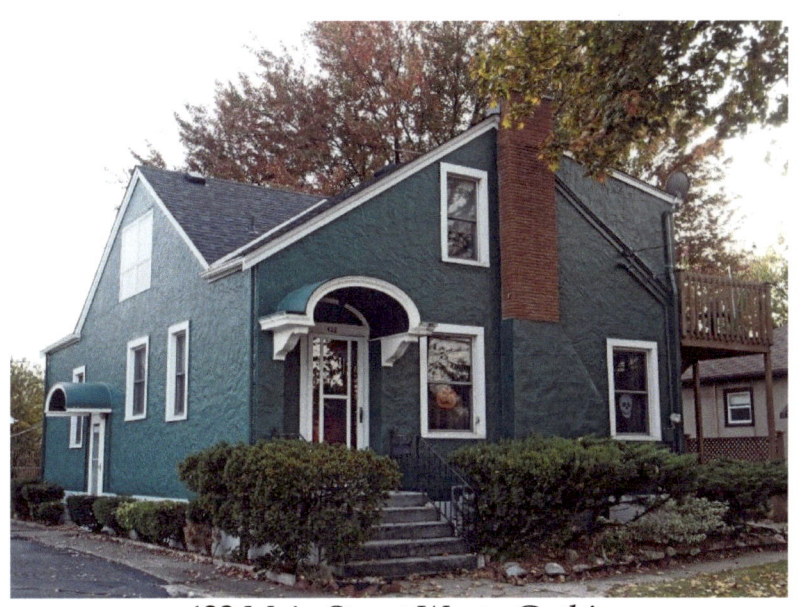

422 Main Street West - Gothic

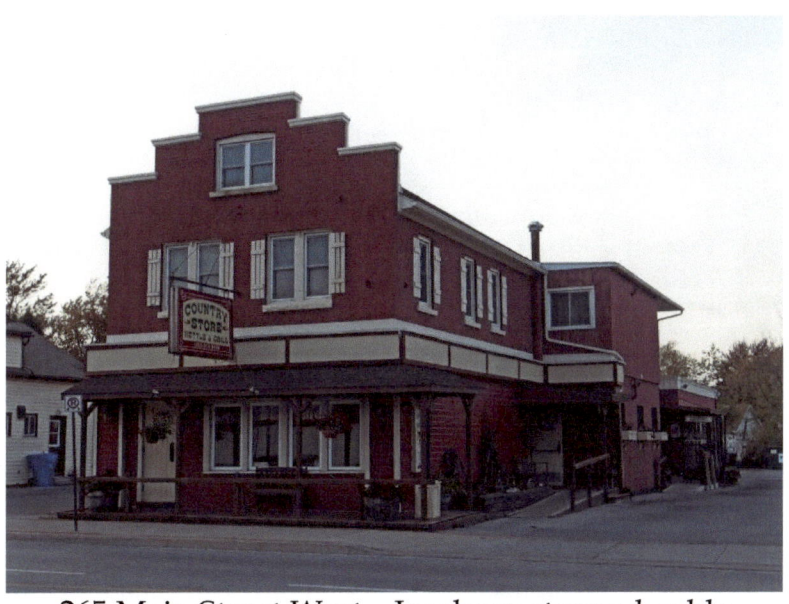

265 Main Street West – Jacobean stepped gable

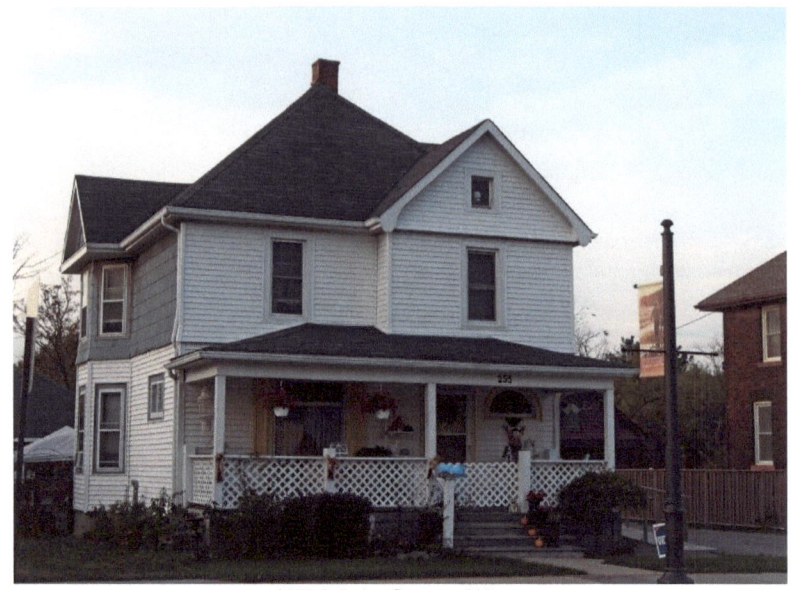

255 Main Street West

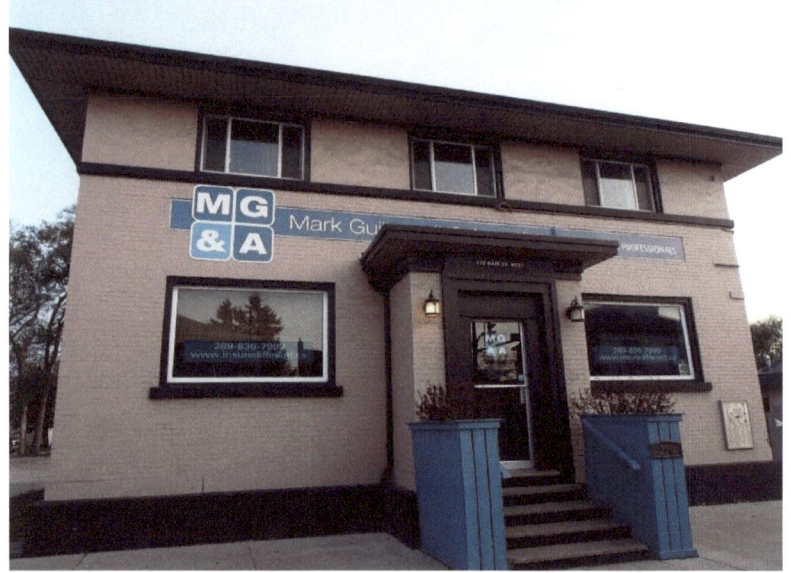

220 Main Street West – Built in 1903 as a post office, this building became home to the Humberstone Branch of the Imperial Bank (later Canadian Imperial Bank of Commerce) in 1905. It is unique in that it has an apartment over the bank for the manager. It closed as a bank in the 1980s. It is now the insurance office of "M G & A – Mark Guilbeault and Associates".

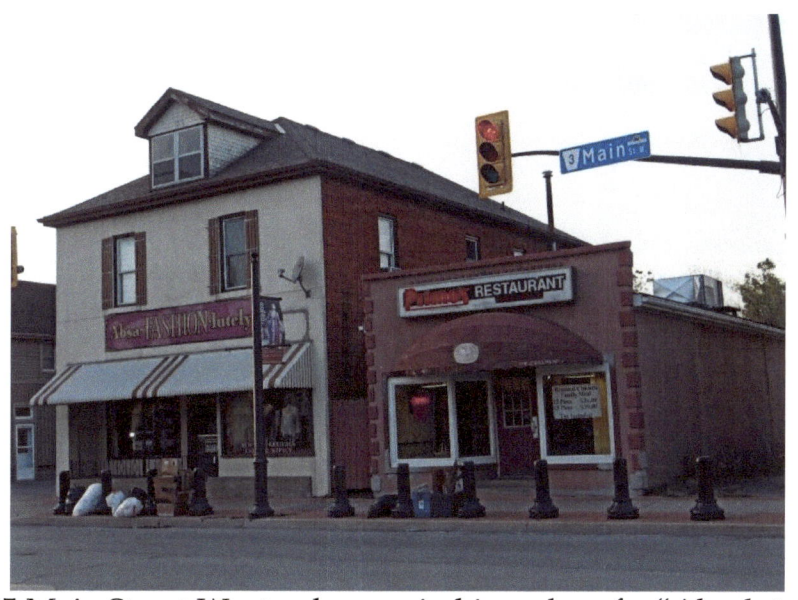

225 Main Street West – dormer in hipped roof – "Absalutely Fashion", and "Primo's Restaurant"

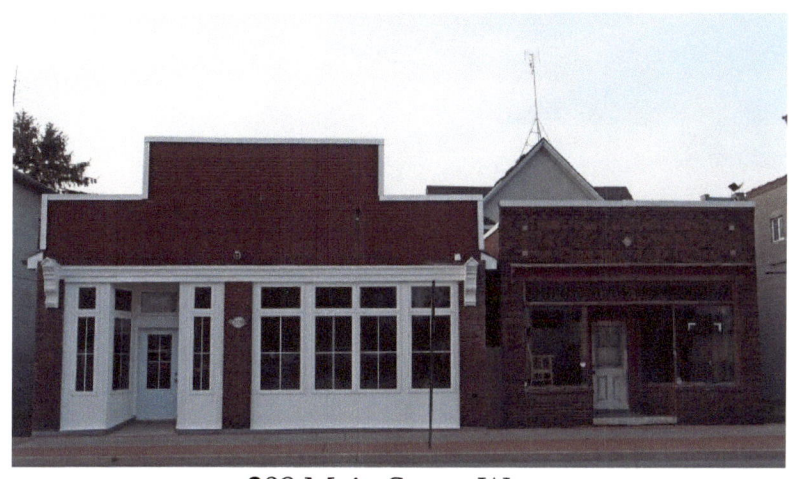

209 Main Street West

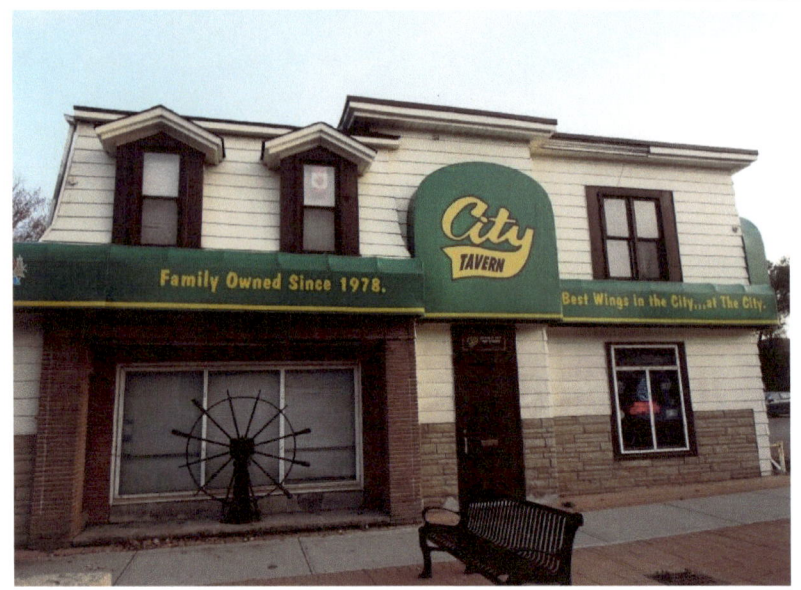

202 Main Street West – "City Tavern" – window hoods on second floor windows

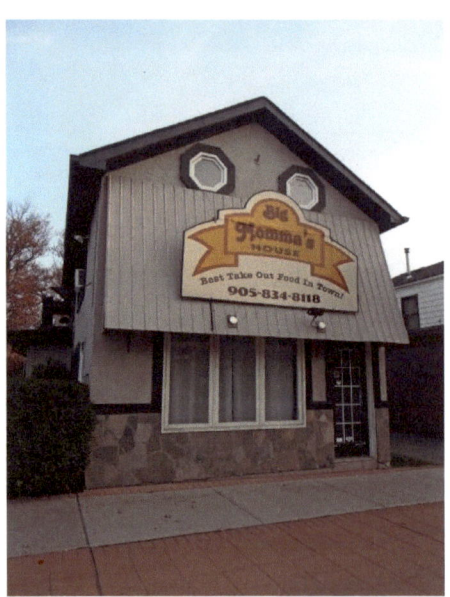

Main Street West – Gothic – "Big Momma's House" – Take-out Food

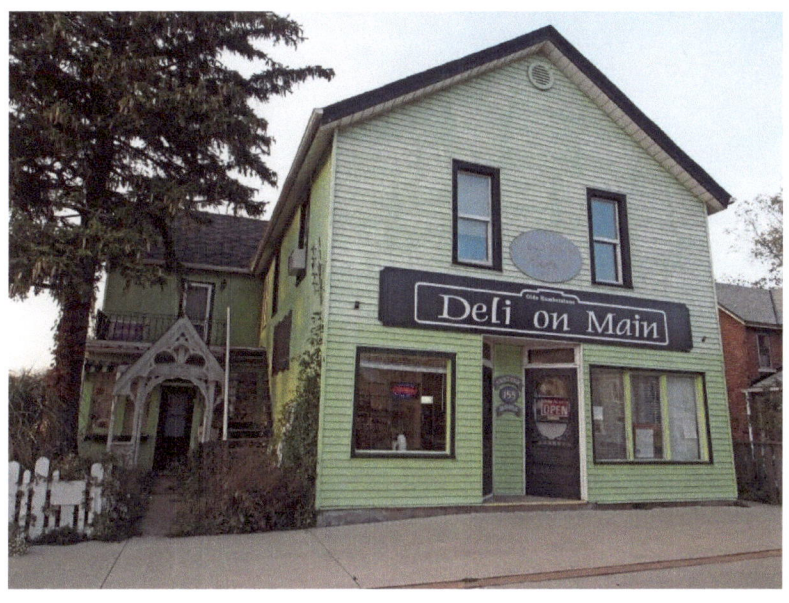

155 Main Street West – The Century House - c. 1889 - The early-twentieth century commercial building was constructed in a vernacular version of the Classical Revival style popular in rural Ontario. It has a flat façade with symmetrical window arrangement and a gable end. It is characteristic of small town store construction of mid-nineteenth century combining a first-floor shop with residence above; it incorporates innovations of later-nineteenth century commercial buildings with larger panes of glass in the shop windows and a recessed store entrance. It is now "Deli on Main".

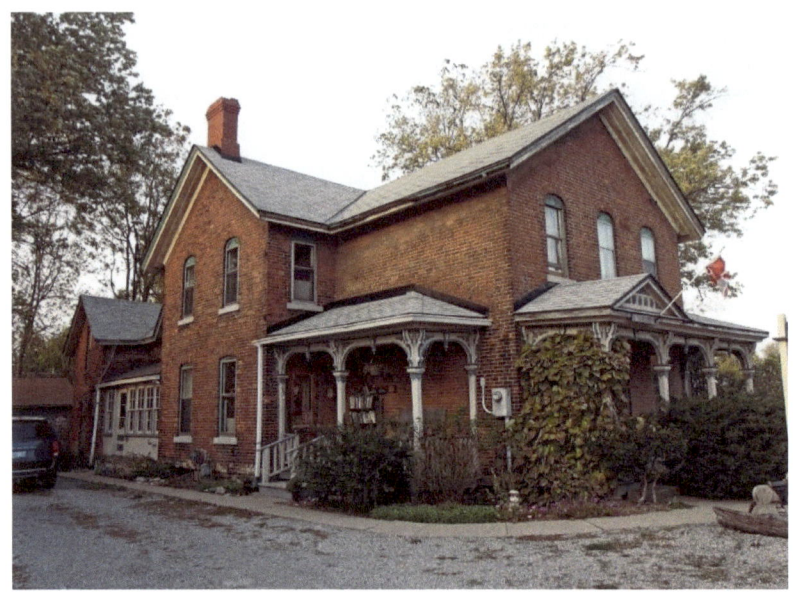

145 Main Street West – The Augustine House was built by Elias Augustine circa 1860, it displays a mixture of mid-nineteenth century detail. The gable front arrangement and symmetrical placement of doors and windows are from the Greek Revival style. The semi-elliptical shape of the openings is an Italianate detail. Note the detailed woodwork of the verandah with its small pediment framing the double-leaved front door. Mr. Augustine was an owner of the carriage manufacturing firm of Augustine and Kilmer. Some production for the business was done in a blacksmith shop formerly located behind the house.

130 Main Street West – Gothic Revival – verge board trim on gable

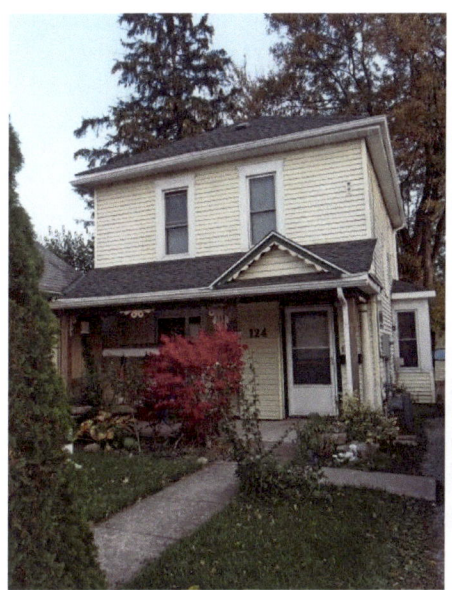

124 Main Street West
Hipped roof, pediment

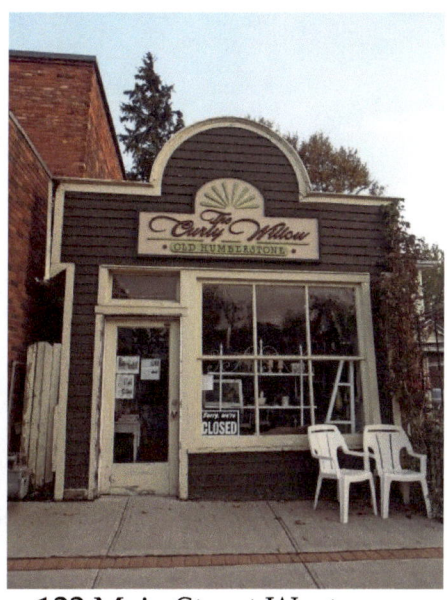

122 Main Street West
"The Curly Willow"

115 Main Street West – The handsome White Block commercial building was built in 1885 and has many details of the Italianate style such as the deeply projecting eaves, and elaborate cornice and brackets. The small centre gable is an unusual classical detail.

106 Main Street West – Gothic

100 Main Street West – hipped roof on front portion, gambrel roof on back section

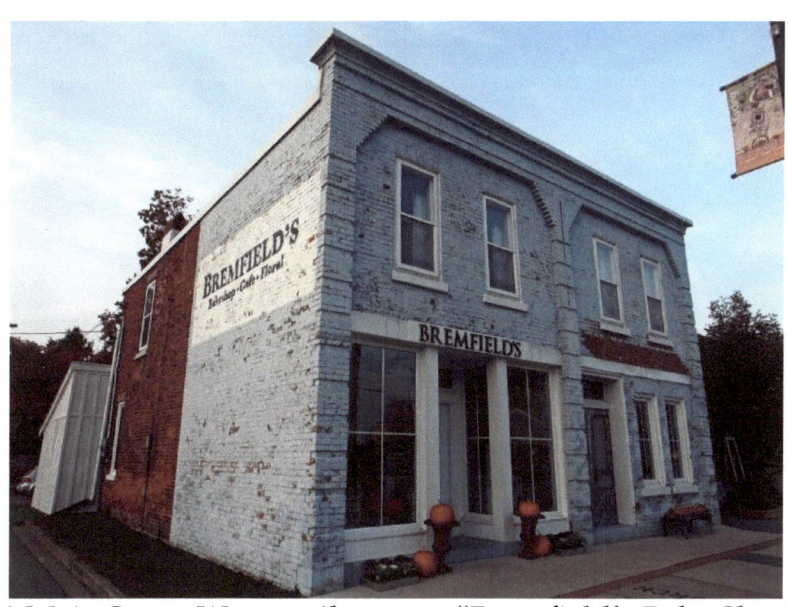

91 Main Street West – pilasters – "Bremfield's Bake Shop"

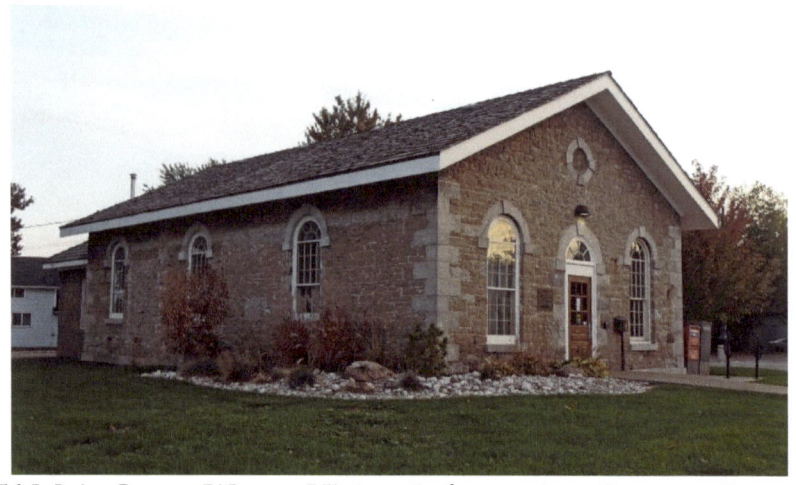

76 Main Street West – Visitor Information Center – It was made from cut stone taken from the Welland Canal. The oldest part of the building, with its multi-paned, arched windows and doors of Palladian influence was designed by architect John Latshaw and was built by A.K. Scholfield in 1852. It was the first town hall for Humberstone. The small addition to the rear (south) was used as a lockup for wayward travellers.

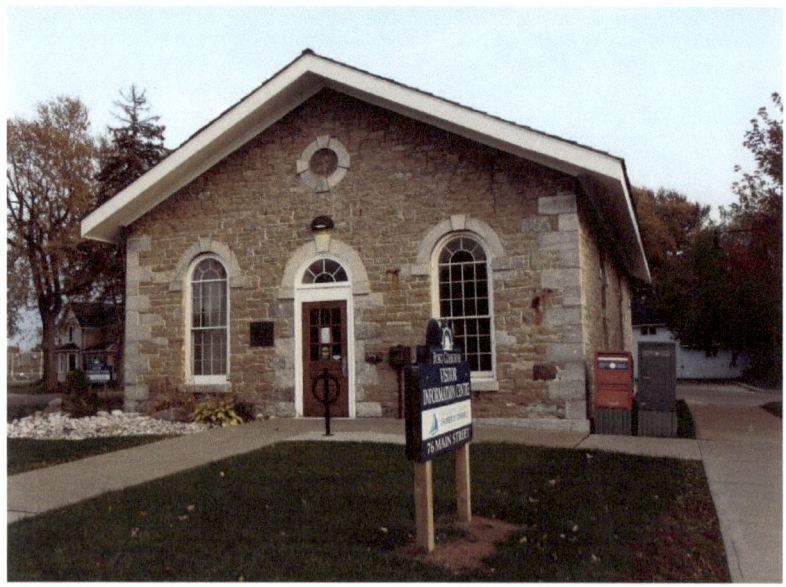

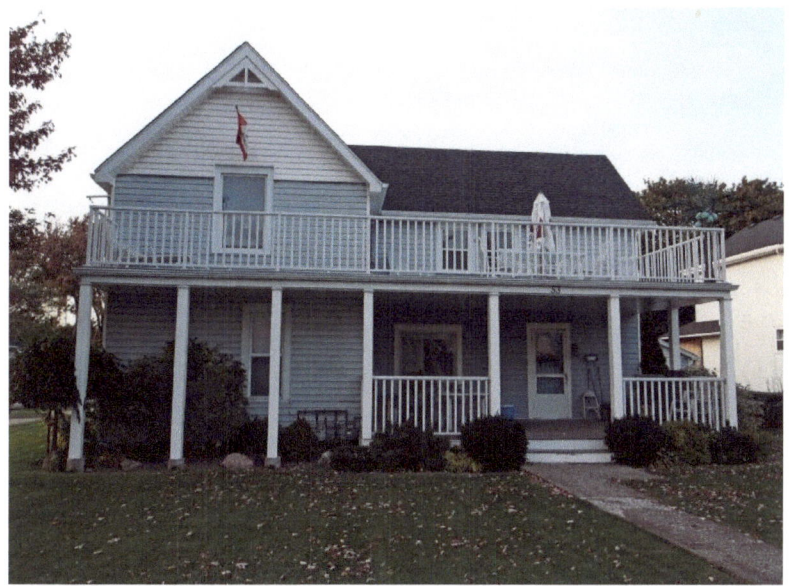

53 Main Street West – trim on peak of gable, full-width second floor balcony

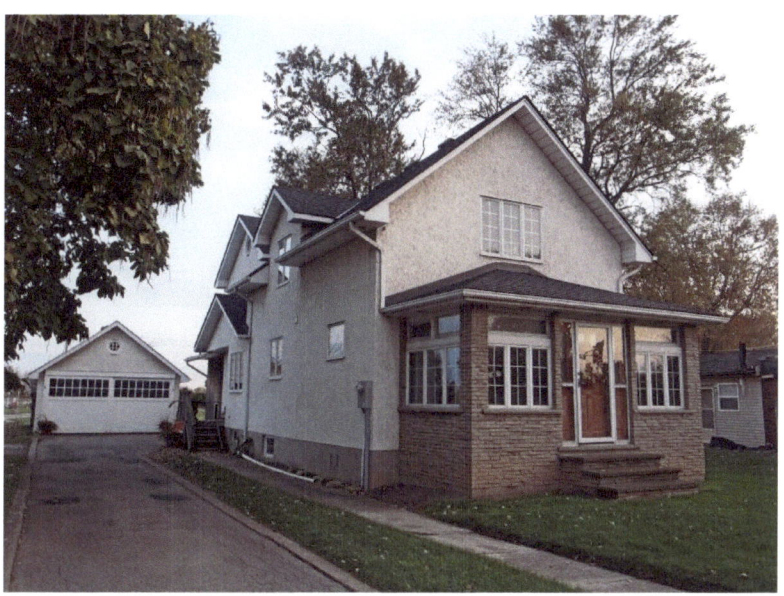

48 Main Street West - Gothic

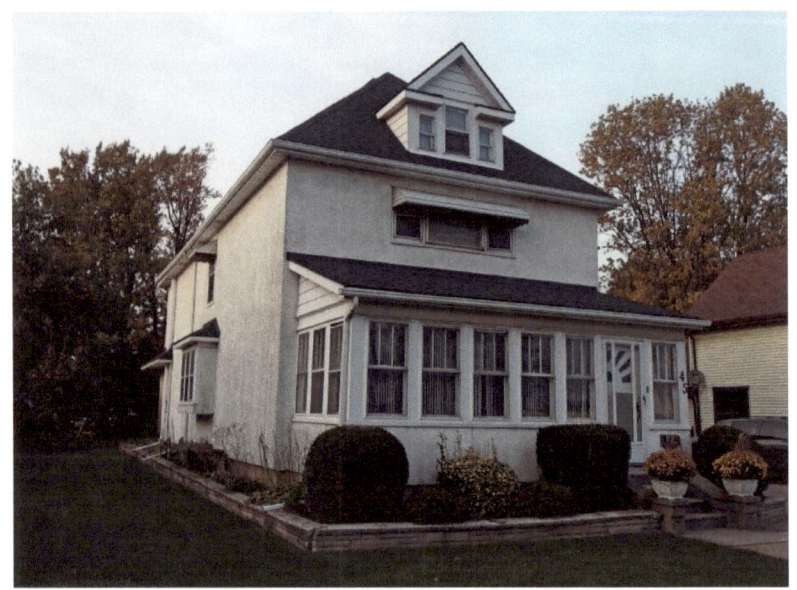

45 Main Street West – hipped roof with dormer

37 Main Street West – cornice return on gable, pediment

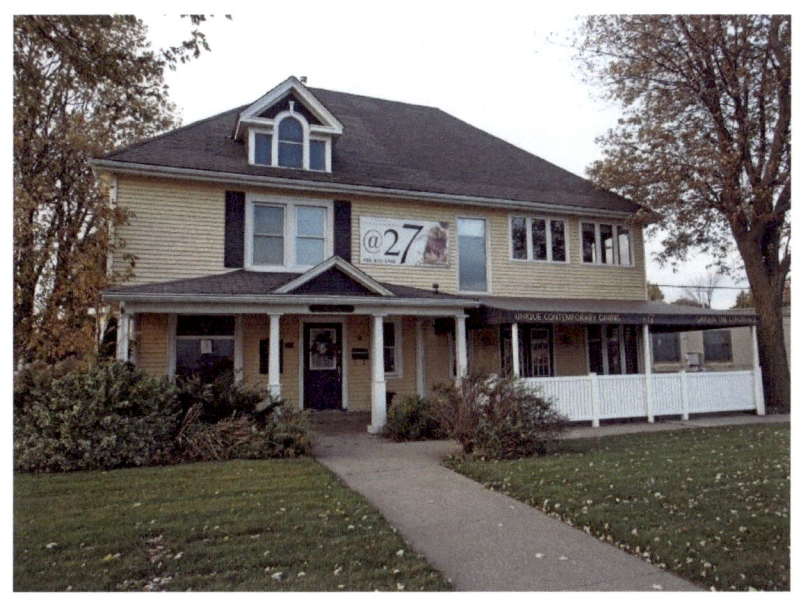

27 Main Street West – hipped roof with dormer and Palladian window

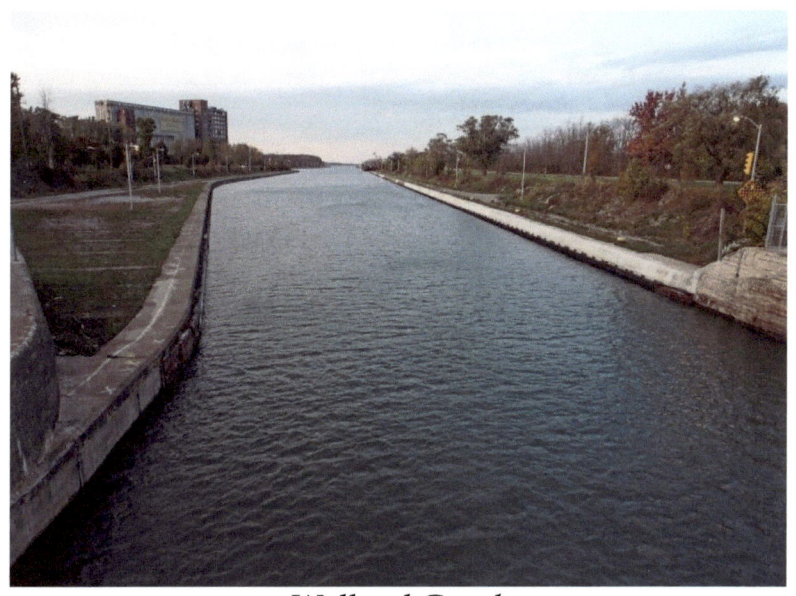

Welland Canal

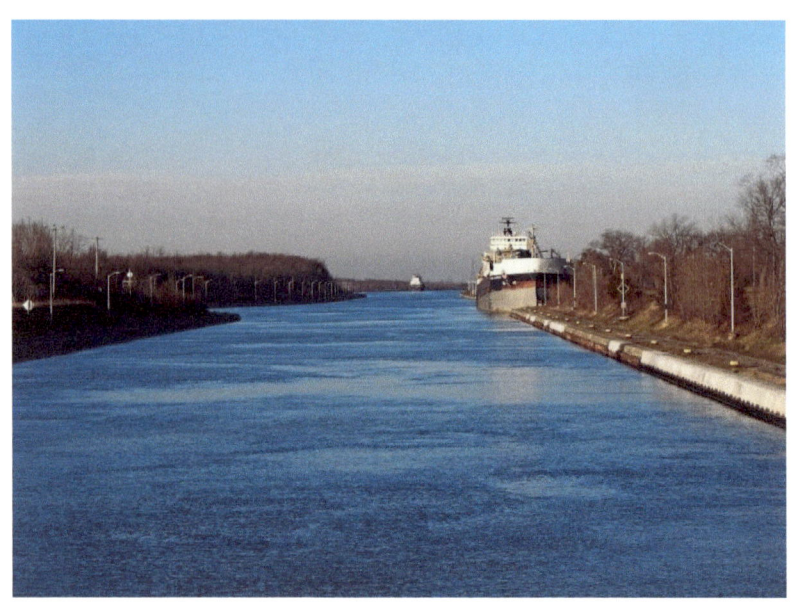

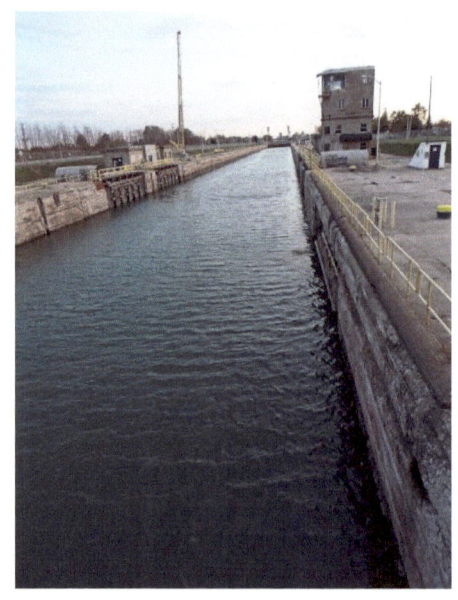

Lock 8 on the Welland Canal raises or lowers ships from one to four feet. It is 420 feet long, one of the longest canal locks in the world. It is the southernmost lock on the canal and many ships take time here to replenish supplies, switch crews, and have minor repairs looked after.

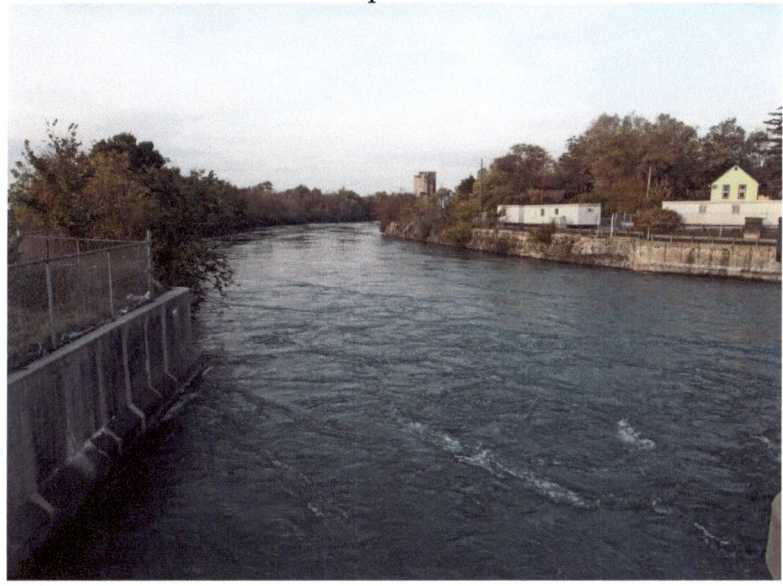

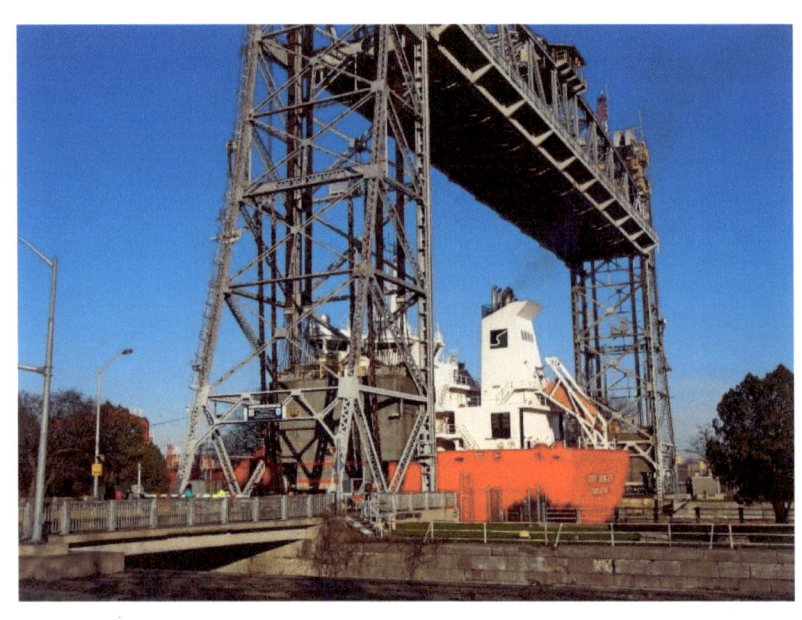

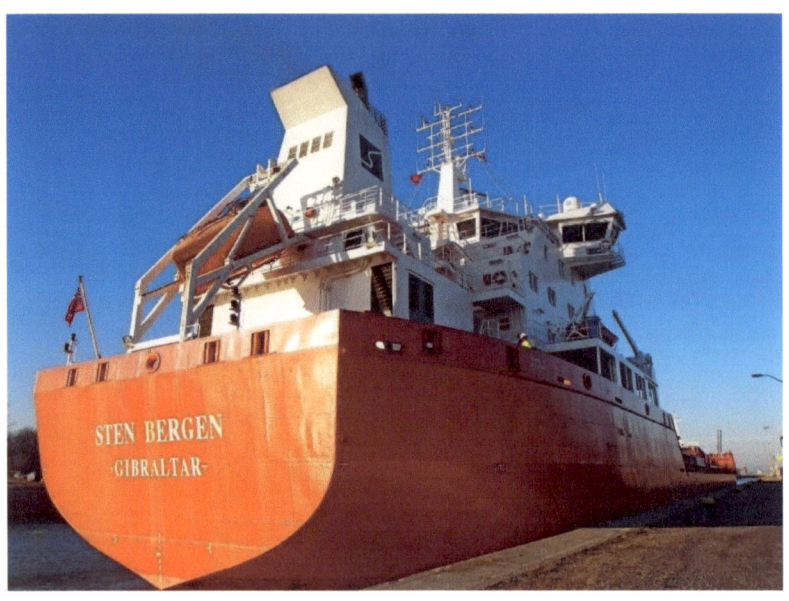

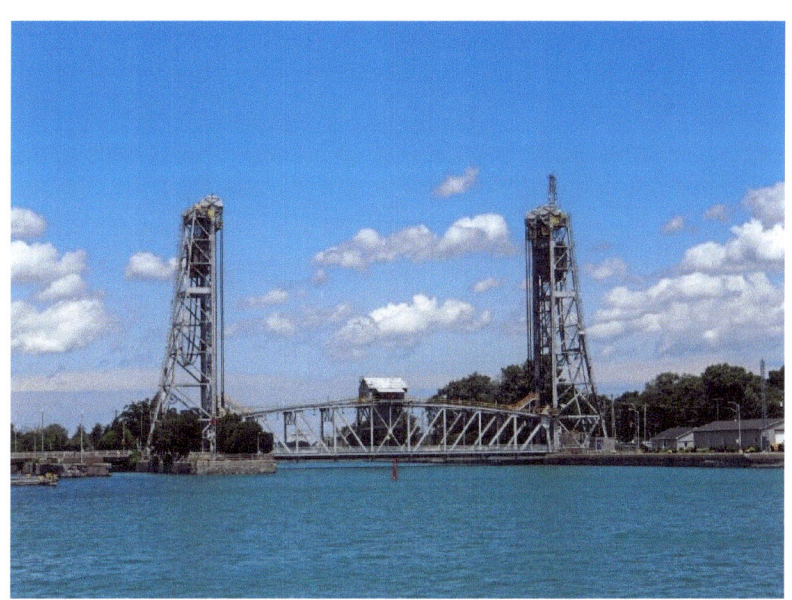

Lift Bridge

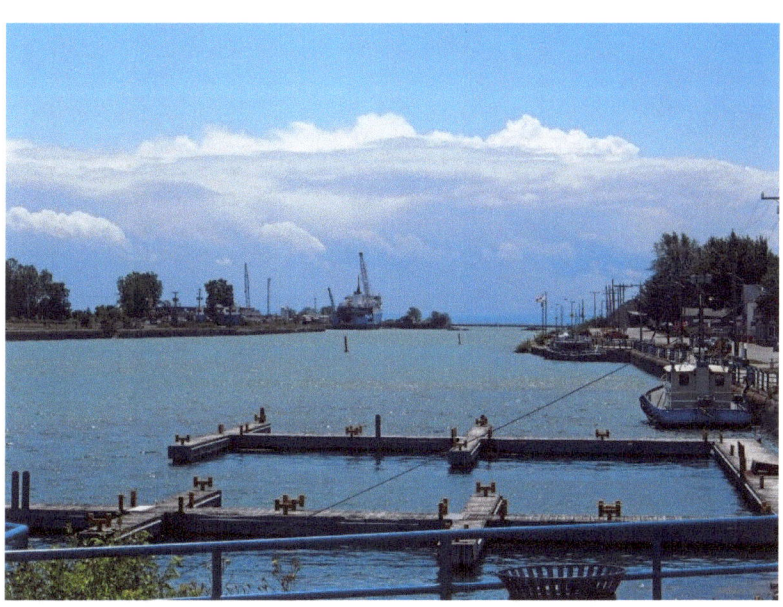

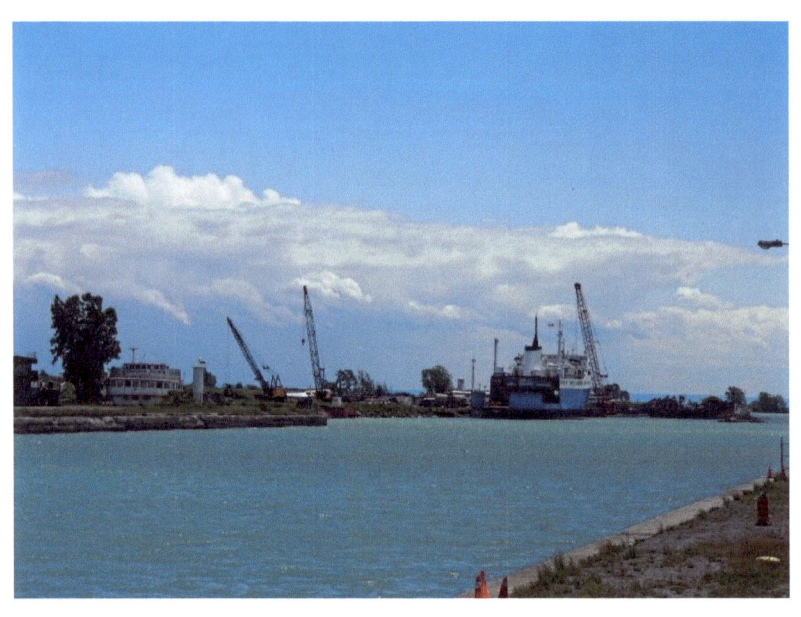

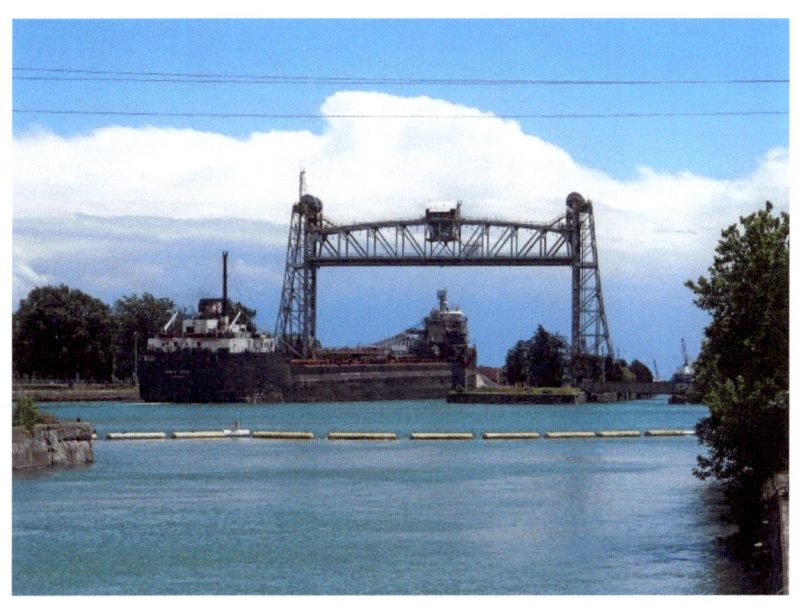

Lift Bridge with ship

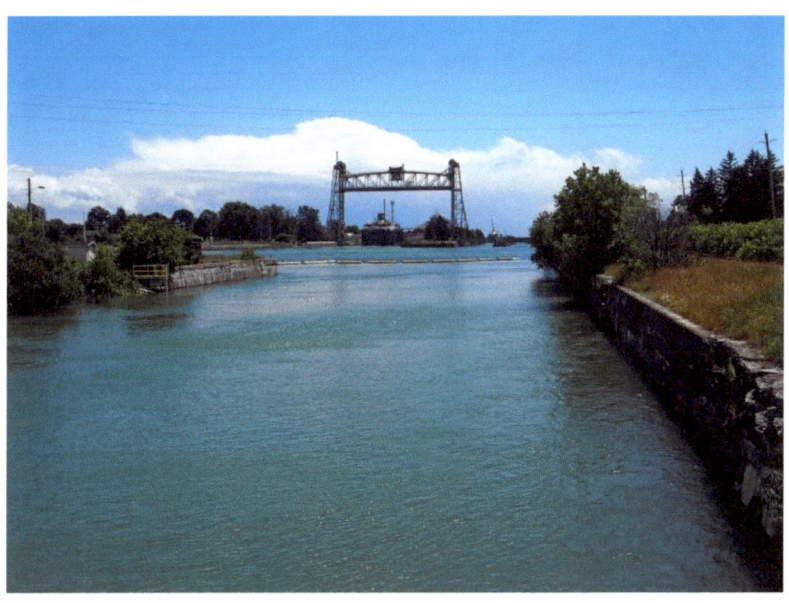

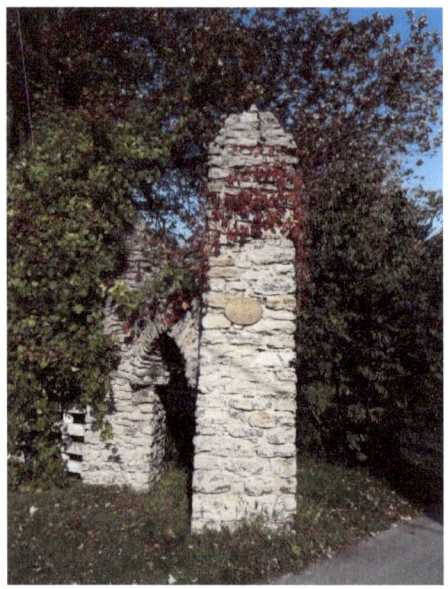

The stone arches that supported the gates that led into the Lorraine Summer resort.

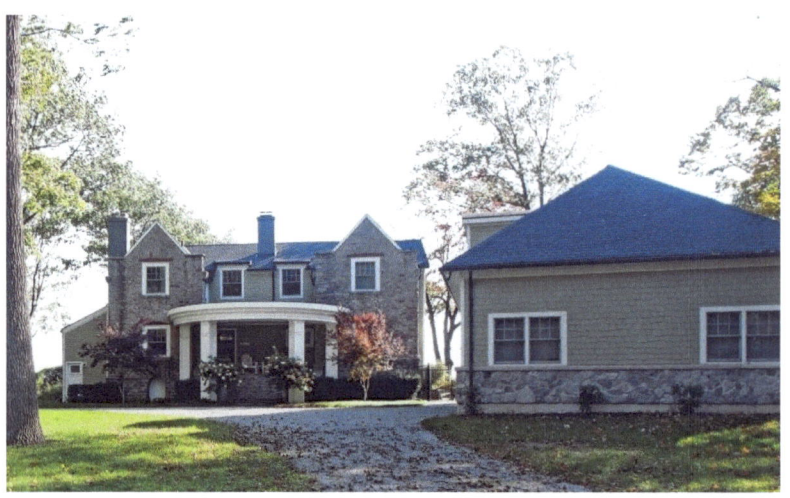

The William Brown House

1001 Firelane No. 1 – Established in 1898 by Frank Fulton Brown and the Dann brothers, the Lorraine Summer resort was located on almost one kilometre of fine sandy beach and named for the Brown's daughter. The structure is a timber frame construction with large, pillar-like stone protrusions on both the front and rear of the building. The cut limestone used is the same as that used to construct the entrance gate pillars on Lorraine Road. The peaked gable ends and the arches above the windows indicate the work of a master stonemason. The architecture is reminiscent of the Richardsonian Romanesque style of architecture.

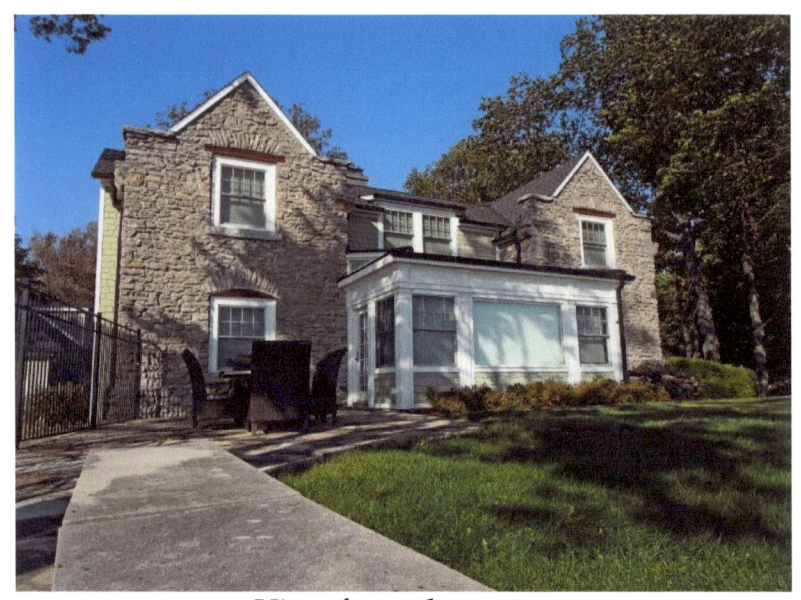

View from the water

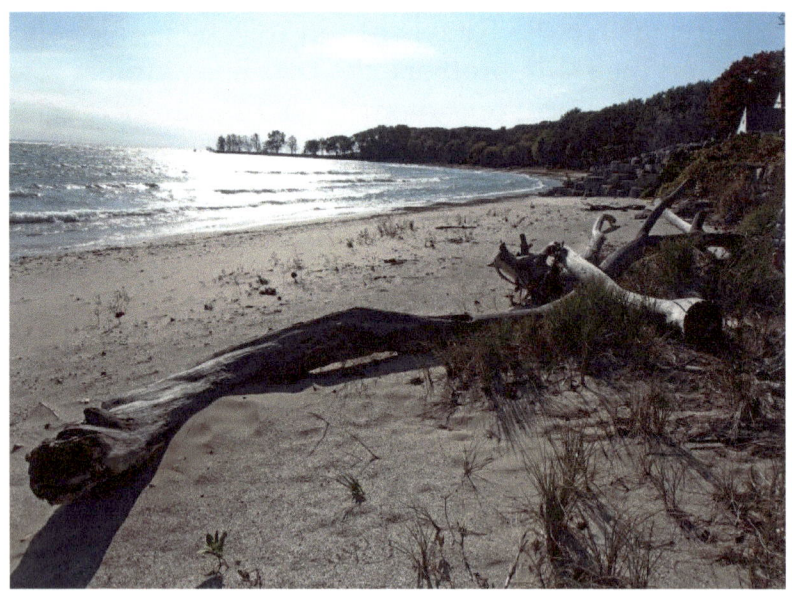

Lake Erie

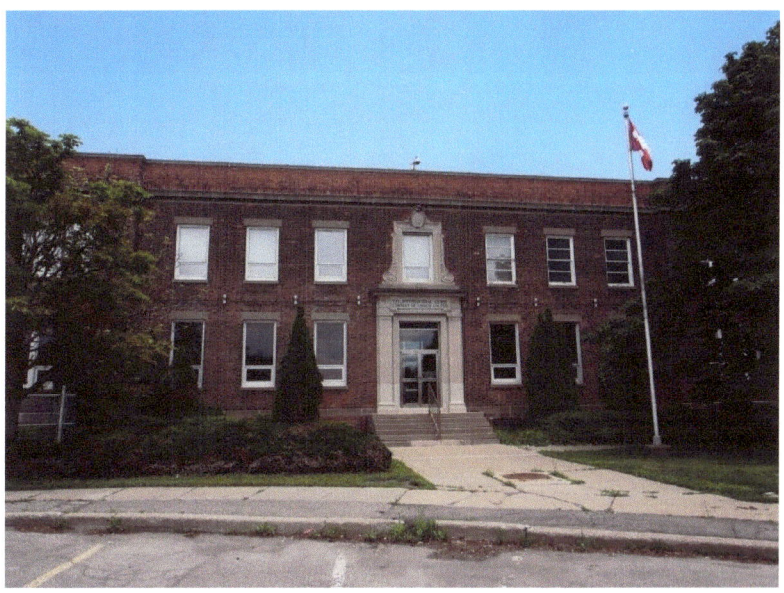

187 Davis Street – International Nickel Administration Building (now Vale) – Opened in 1918, it was the largest nickel refinery in the world until the 1930s.

Original buildings

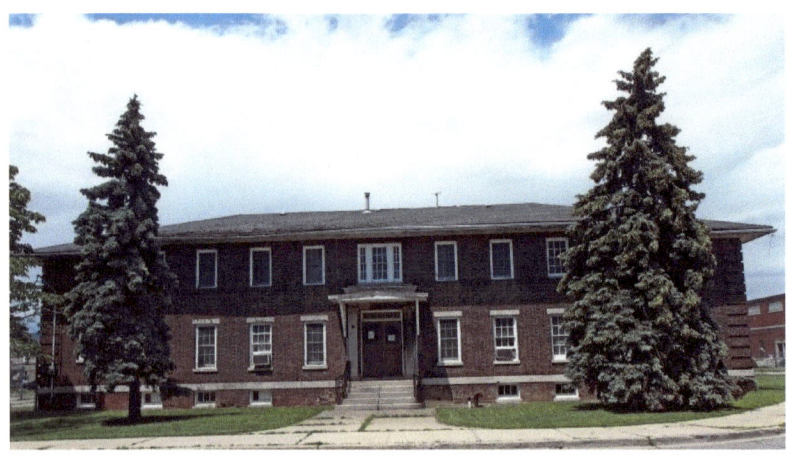

Davis Street – International Nickel (now Vale) building

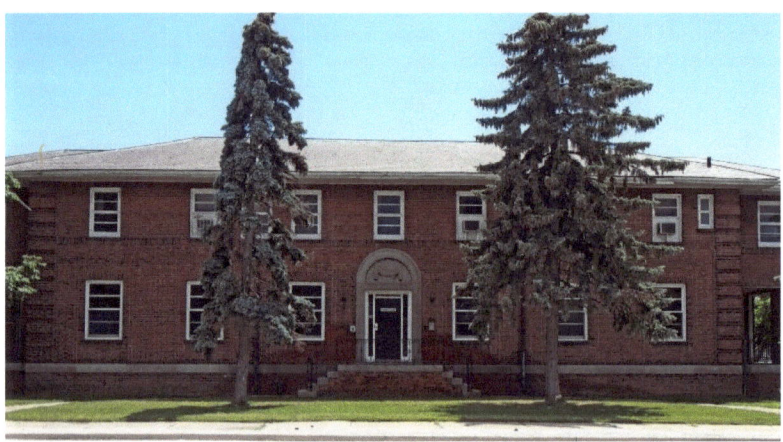

Davis Street – International Nickel Training Centre (now Vale)

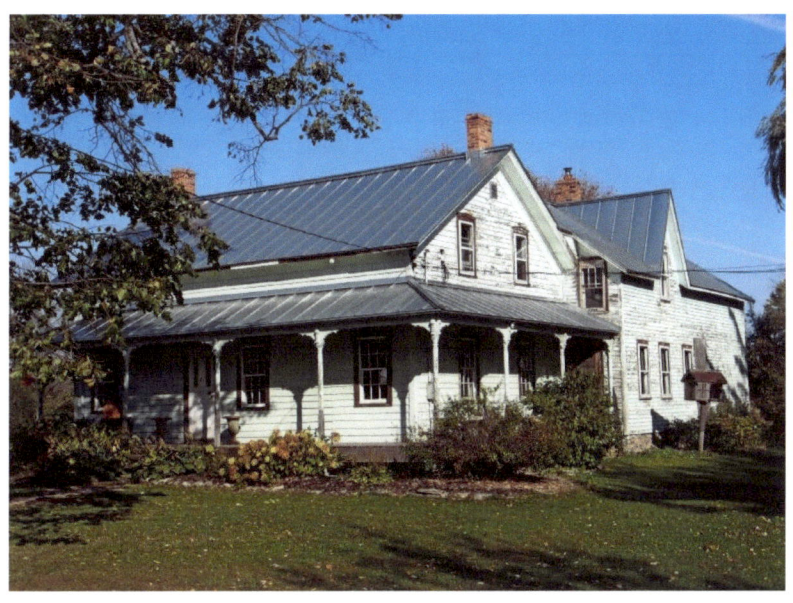

1271 Sherk Road – The property was passed on to David Sherk, son of Casper Sherk, in April 1806. The Sherks came from Pennsylvania and were among the first families to settle in Humberstone. During the mid-1870s, an Ontario farmhouse was built near the centre of the lot. The house is an excellent example of nineteenth century farm house building styles and techniques. It displays features of Regency, Gothic and Italianate styles of architecture. Regency detailing is seen in the large first floor windows and wraparound porch. Gothic styling is in the deep eaves and scrollwork on the porch posts, and the vertical and horizontal clapboard siding. The Vernacular Ontario Gothic Cottage addition has large multi-pane, sash-type windows with Italianate hooded surrounds, end chimneys and a fieldstone foundation.

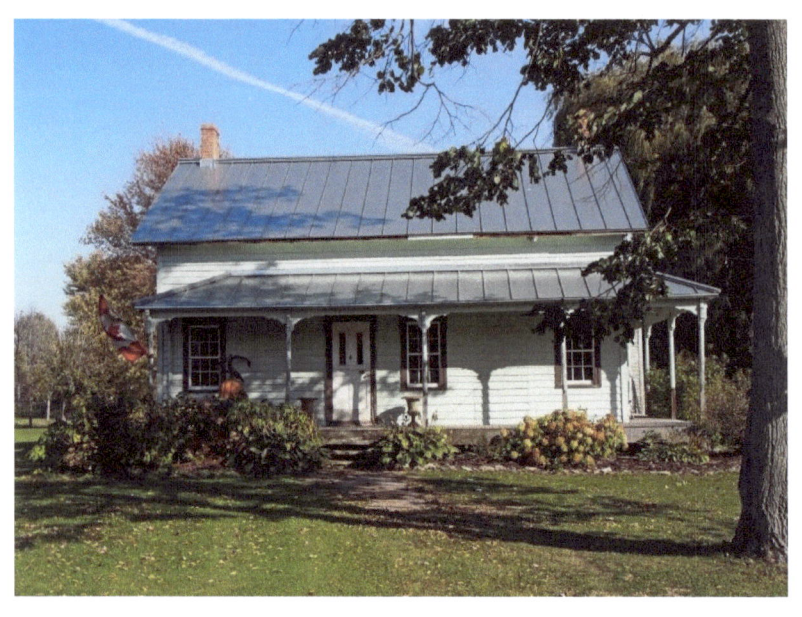

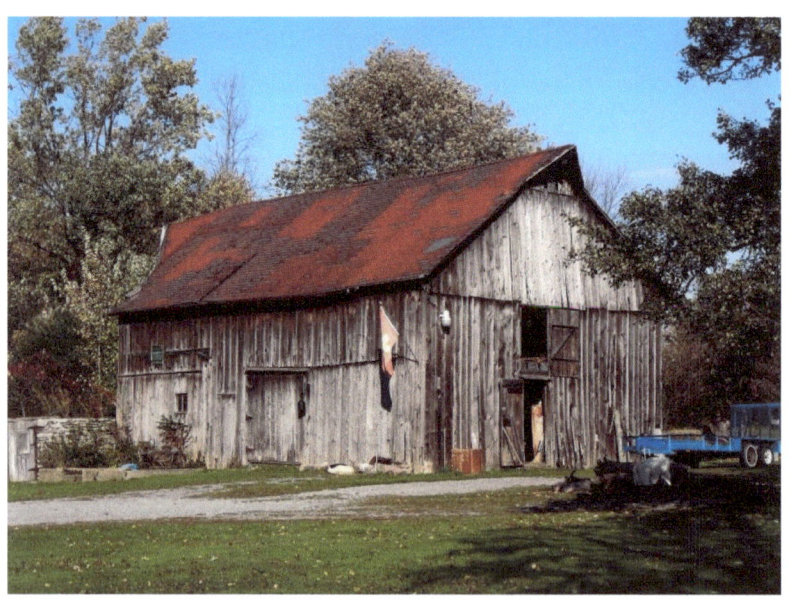

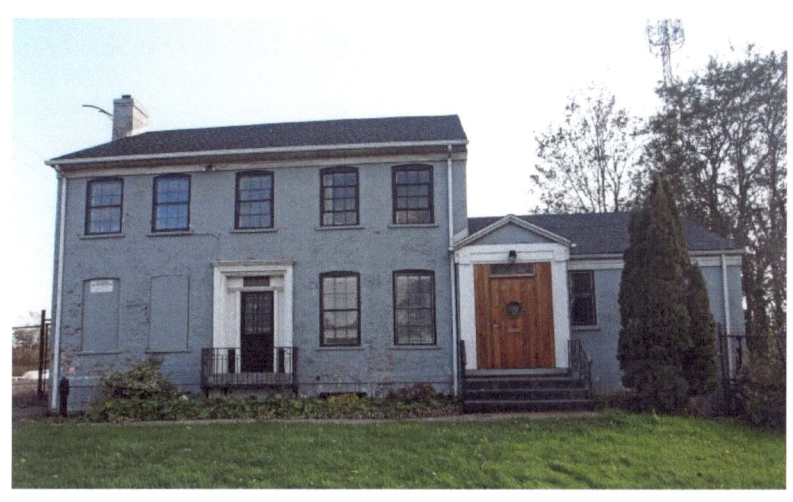

1 Lake Street – This Georgian style house was built in 1852 by Jacques "Jacob" North, a second-generation brew master who emigrated from Alsace-Lorraine, France. It has a balanced and symmetrical façade, six-over-six windows, and a central doorway (formerly surrounded by transom and side windows). The brewery was built at the same time and was located just behind the existing structure. In 1875 Jacob sold the brewery to Henry Cronmiller and Thomas White and there famous Indian Head lager was shipped all over the province. In about 1898, the company began producing ginger ale and "whipped cream", a white cream soda. Prohibition forced the business to close in 1919.

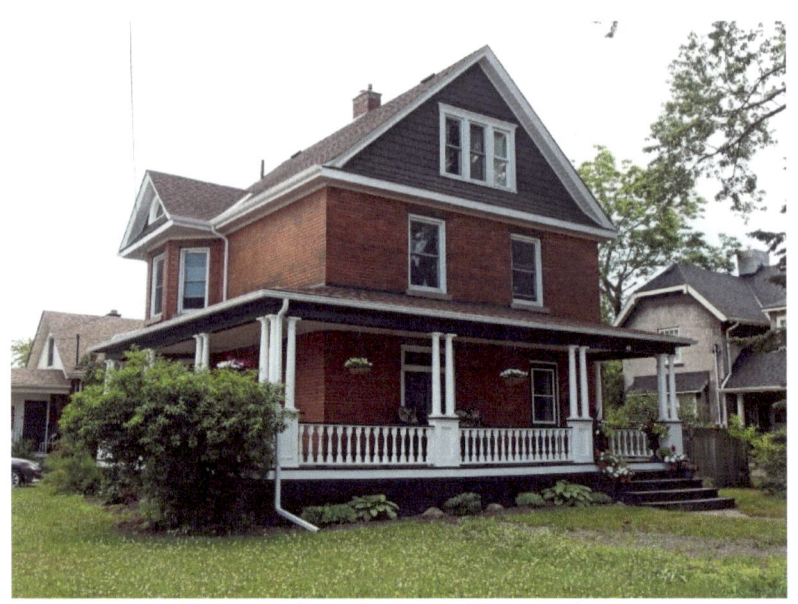

40 Sugarloaf Street - Edwardian

Sugarloaf Street – two-storey tower-like bay with pediment. Third-floor balcony on side

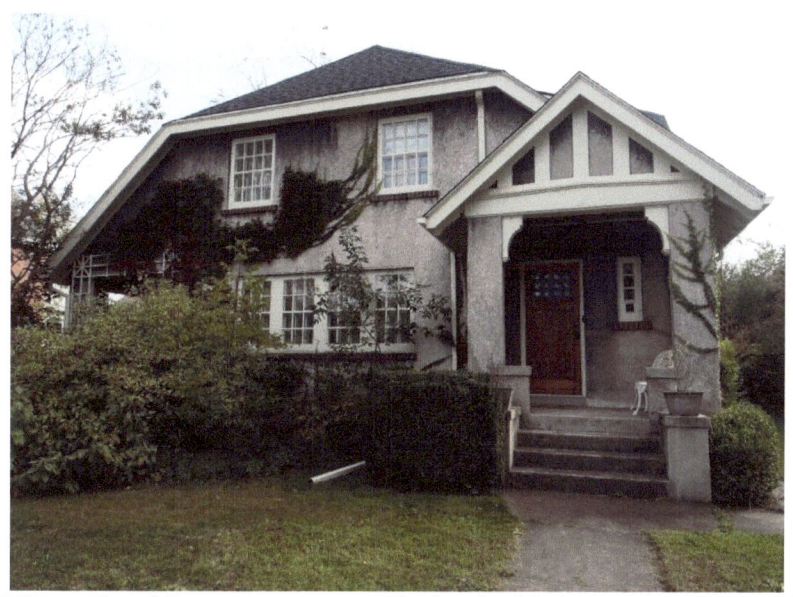

48 Sugarloaf Street – stucco, Tudor half-timbering on gable above porch

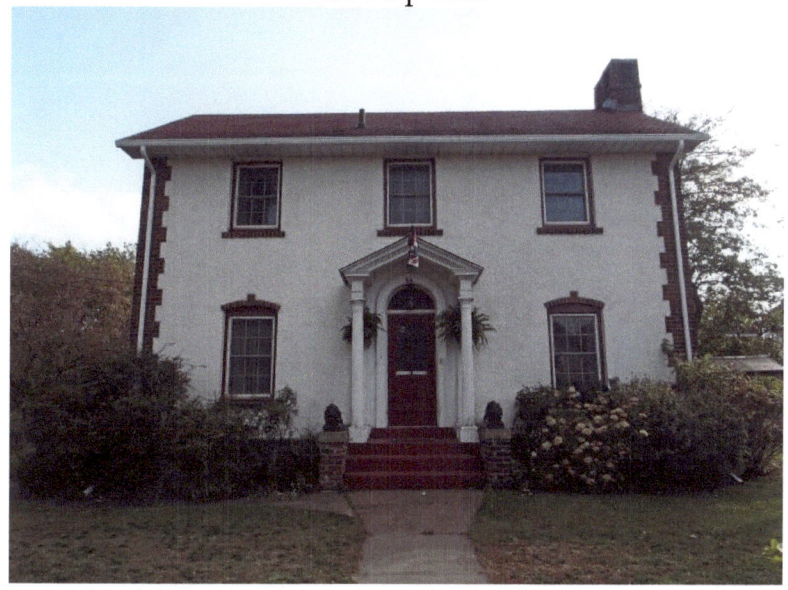

54 Sugarloaf Street – hipped roof – Georgian style – balanced façade, four pillars supporting the porch's open pediment, corner quoins

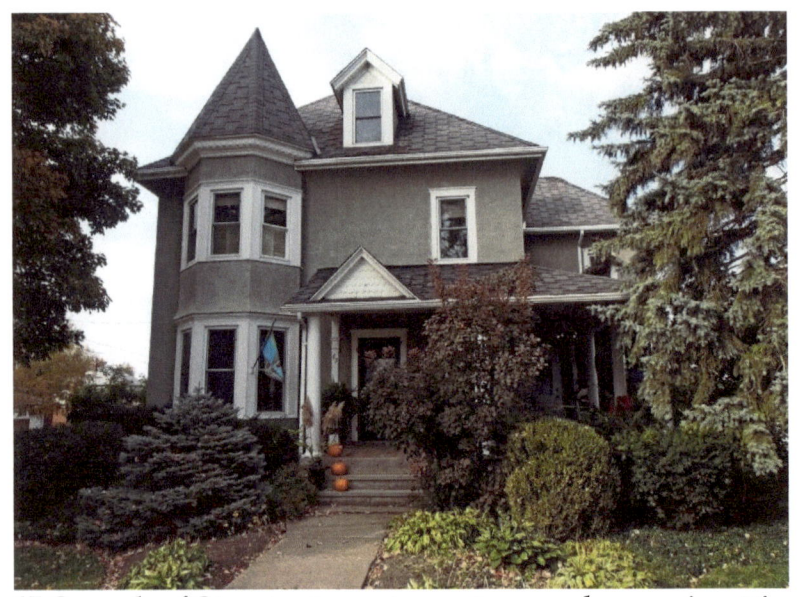

65 Sugarloaf Street – two-storey tower, dormer in attic, pediment

Sugarloaf Street - Gothic

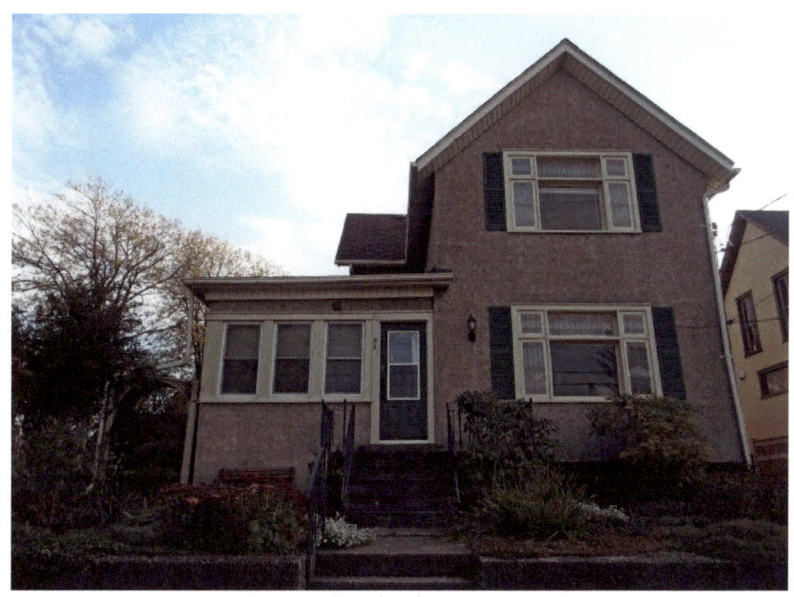

86 Sugarloaf Street - Gothic

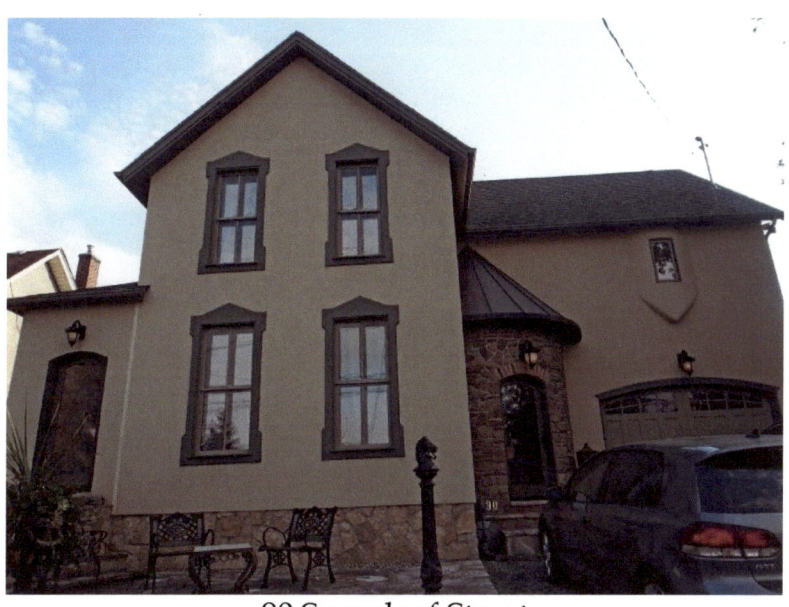

90 Sugarloaf Street

100 Sugarloaf Street – Italianate with 2½- storey frontispiece, pediment with decorated tympanum, open railing on veranda

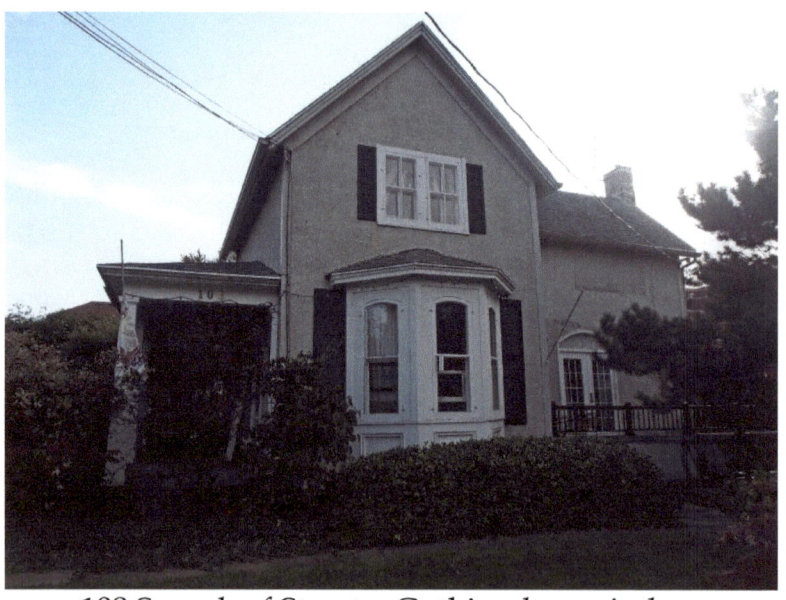

108 Sugarloaf Street – Gothic – bay window

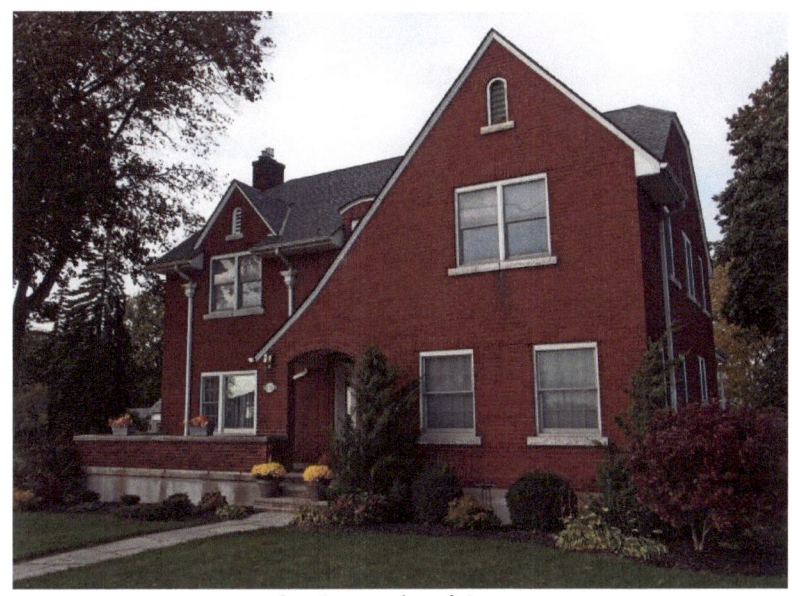

131 Sugarloaf Street

Sugarloaf Marina

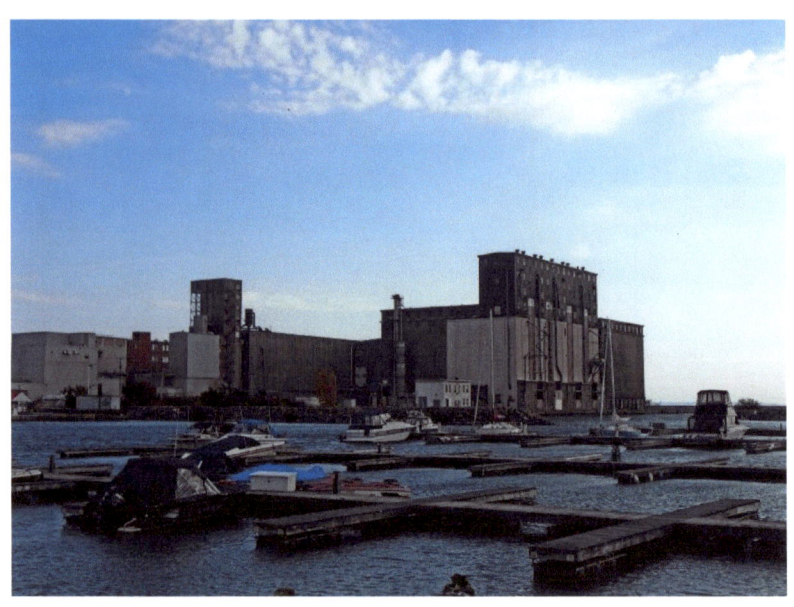

Sugarloaf Marina

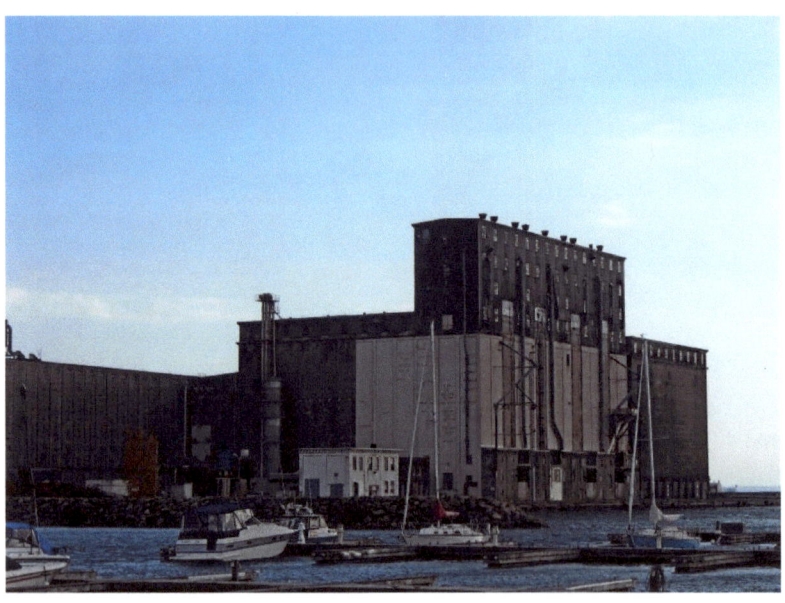

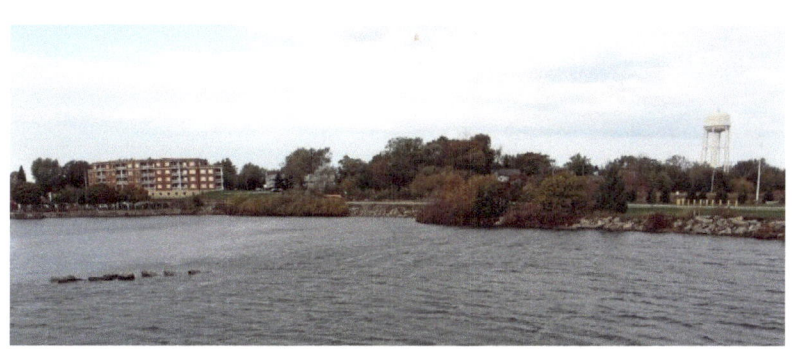

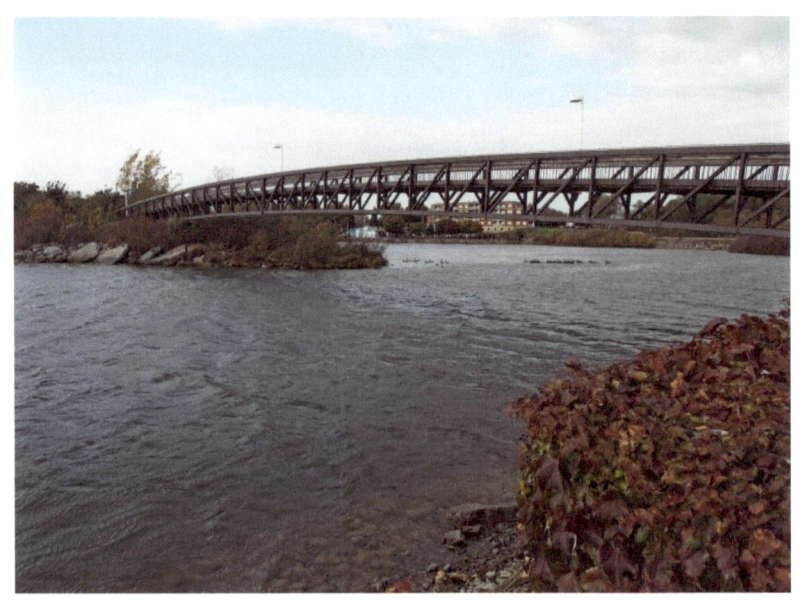

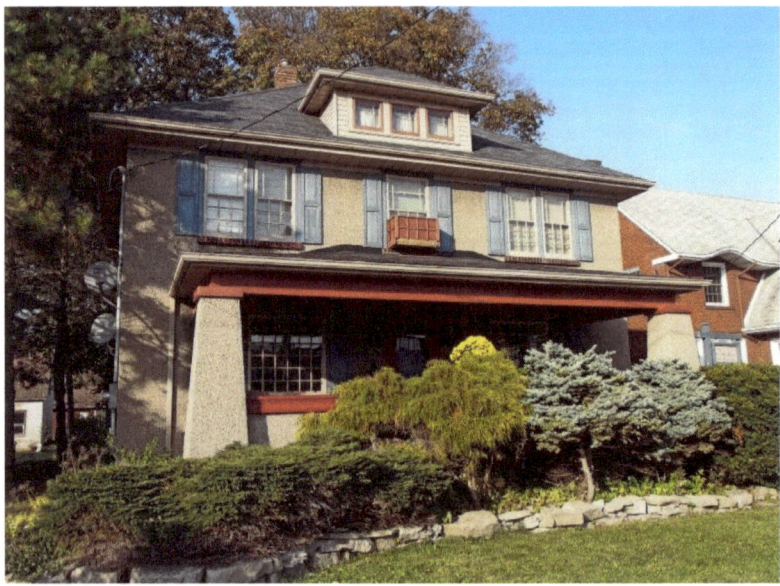

Sugarloaf Street

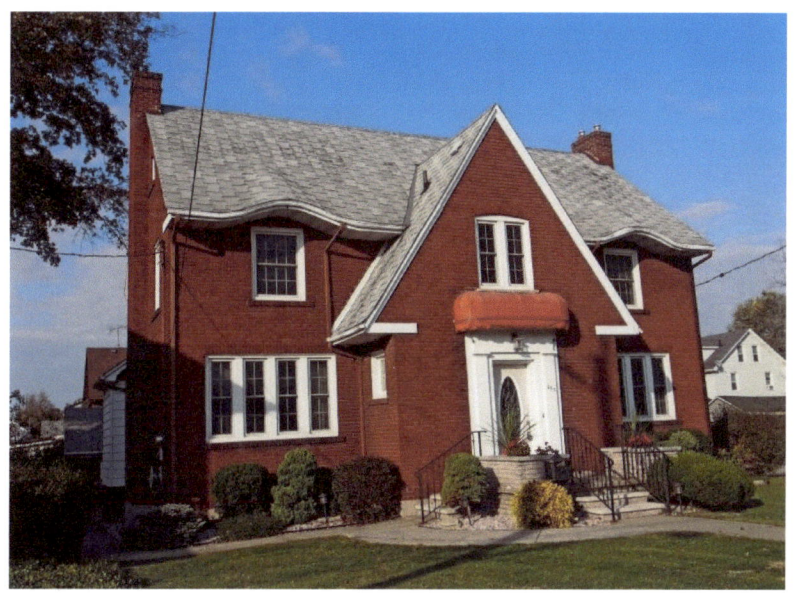

253 Sugarloaf Street

Sugarloaf Street

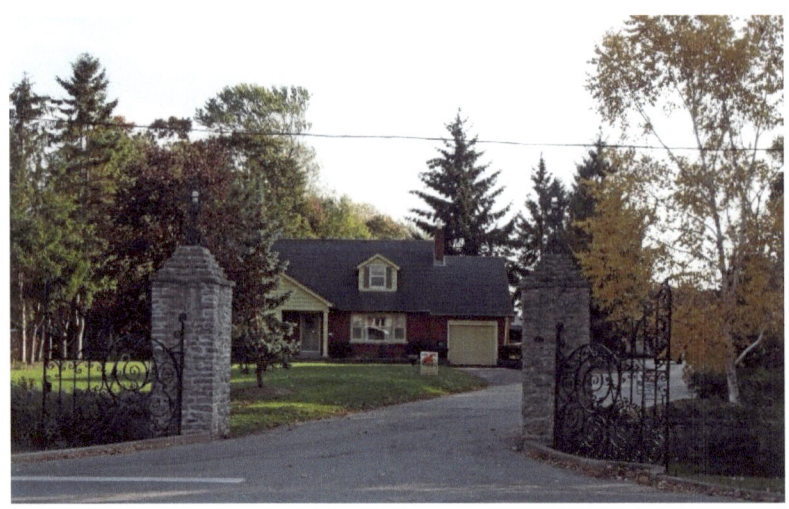

Tennessee Avenue Gates – Built in 1898, the limestone pillars and gates are a reminder of a former magnificent summer colony called the "Humberstone Club" which was commonly known as "Solid Comfort." The stone used was local limestone with the masonry work done by Ed Wegerich and his father of Port Colborne. The wrought iron gates were manufactured in Toronto.

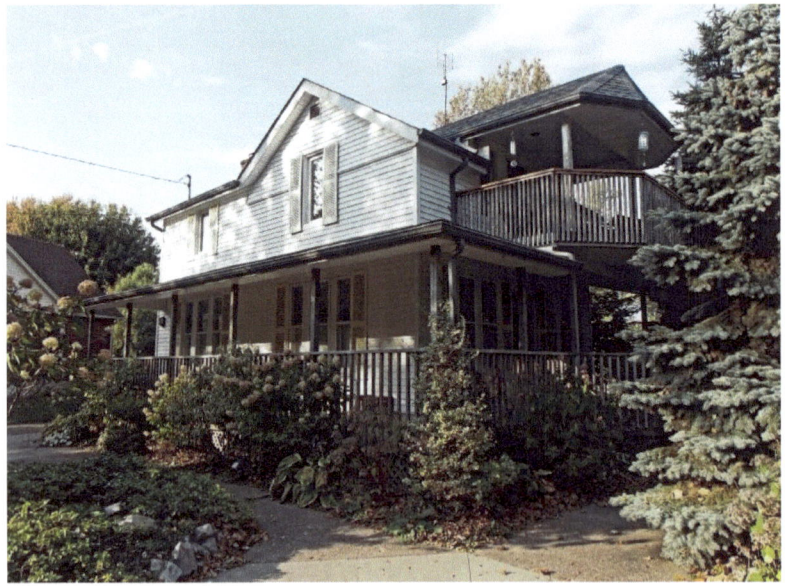

Tennessee Avenue – second floor balcony

19 Tennessee Avenue – The former Humberstone Club Casino was built in 1912 and was used as a games and social centre. Architectural features of interest include the eyebrow window and chipped gables.

33 Tennessee Avenue – two-storey bay window

Tennessee Avenue – bay window

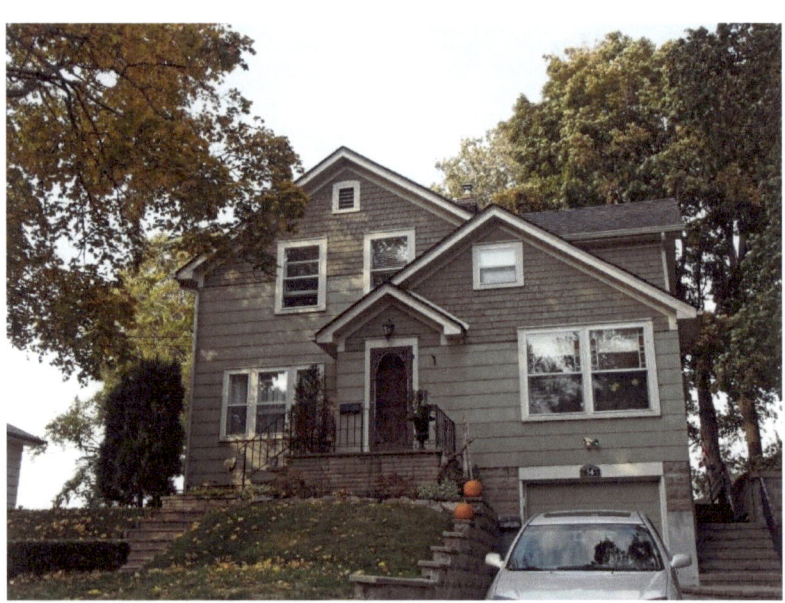
54 Tennessee Avenue

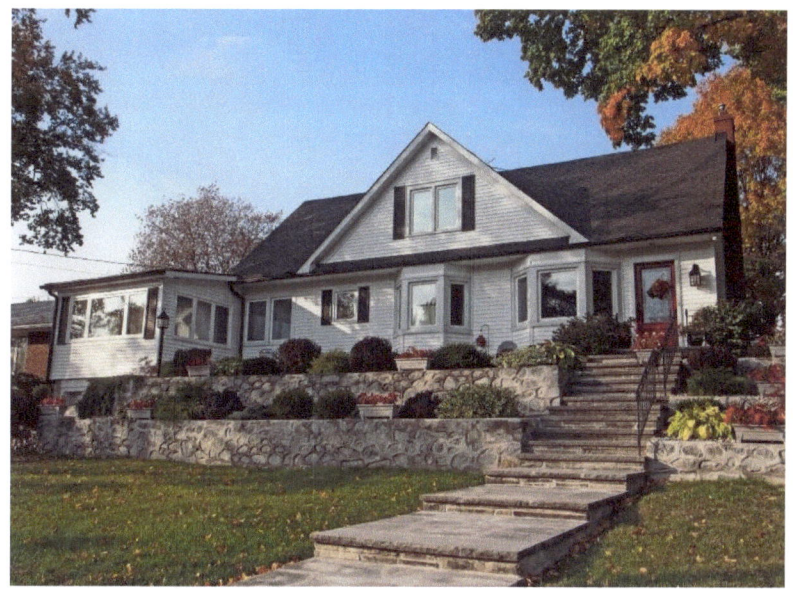

Tennessee Avenue – bay windows

Tennessee Avenue – trim and finial at peak of gable

89 Tennessee Avenue

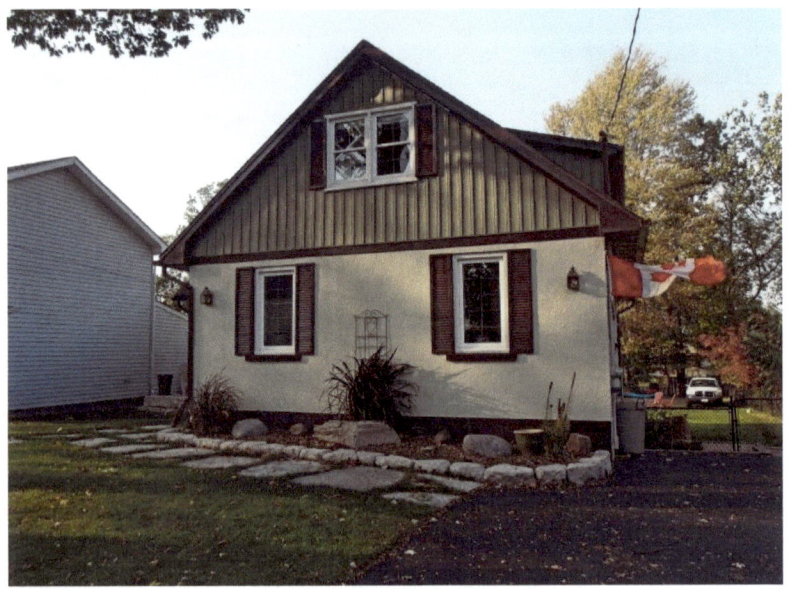

Tennessee Avenue

113 Tennessee Avenue

119 Tennessee Avenue

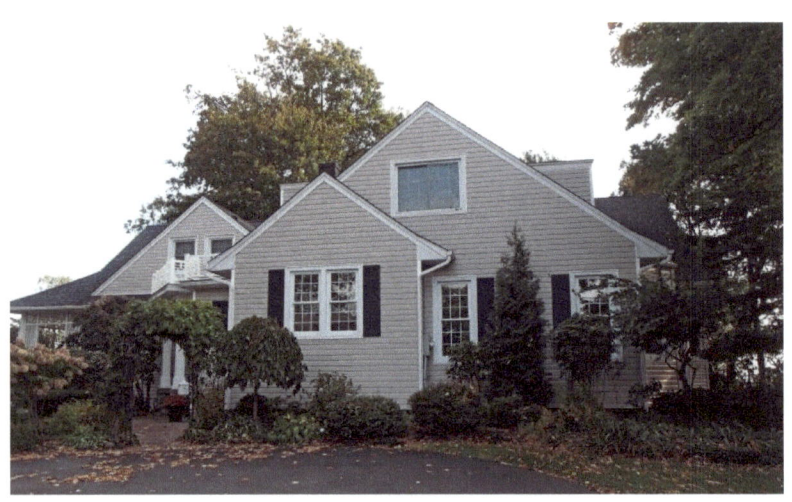

125 Tennessee Avenue

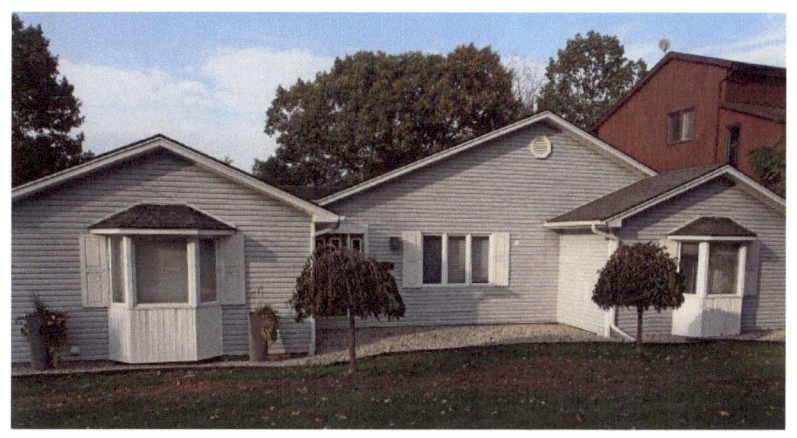

Tennessee Avenue

88 Steele Street - Neo-colonial – gambrel roof, shed dormer

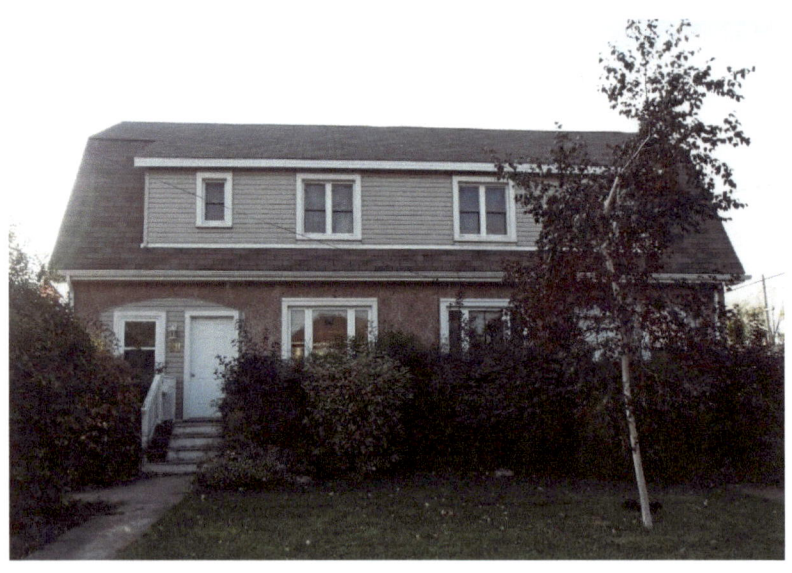

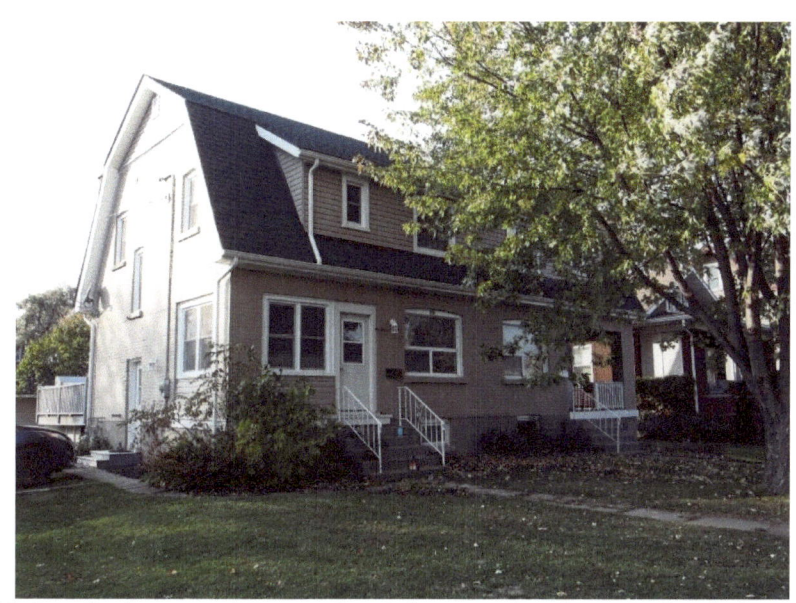

102 Steele Street – Neo-colonial – gambrel roof, shed dormer

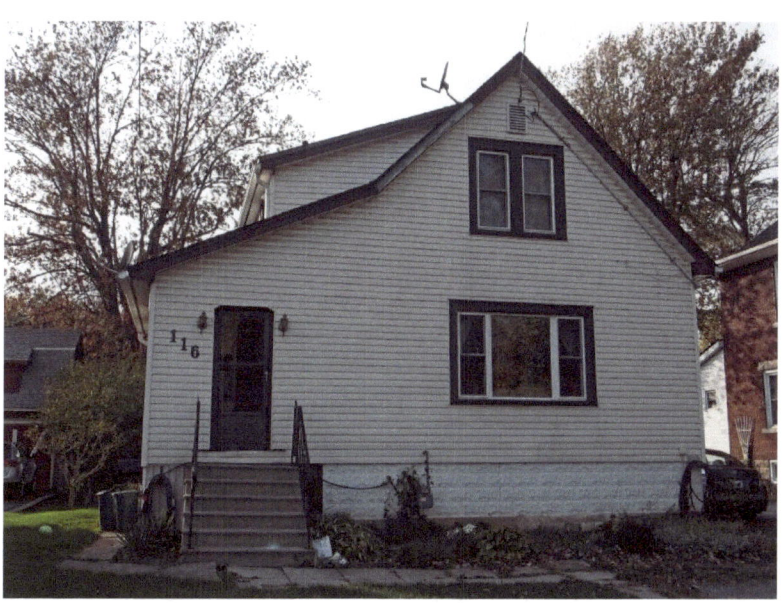

116 Steele Street

124 Steele Street – hipped roof with dormer

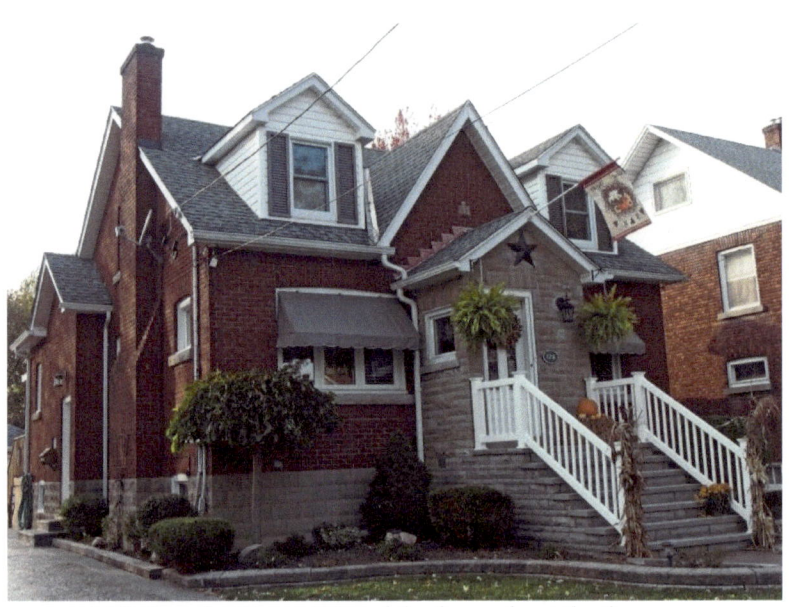

128 Steele Street – gabled roof with dormer

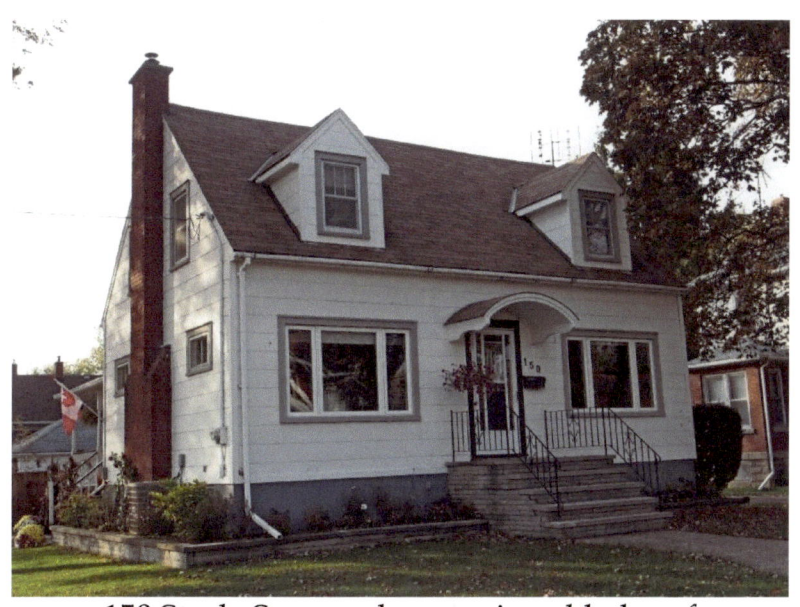

150 Steele Street – dormers in gabled roof

168 Steele Street - Gothic

172 Steele Street – hipped roof with dormers

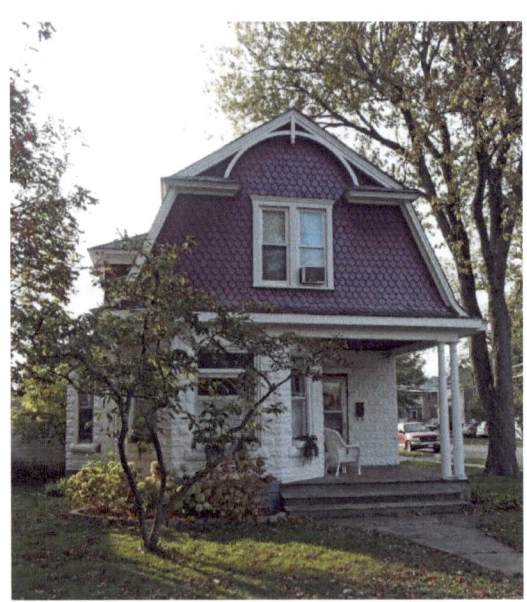

178 Steele Street – vernacular

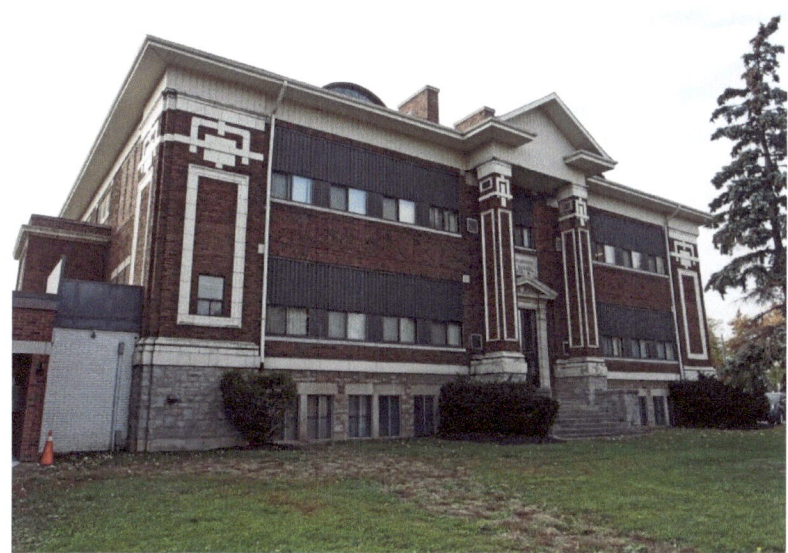

214 Steele Street – Steele Street Public School – The symmetrical red brick façade trimmed with yellow terra cotta tile with an impressive central pediment show the dignified Edwardian Classical style, the style that was at the height of its popularity in 1915 when the school was built. The school and the street were named for the Steele family who were early settlers of Humberstone Township.

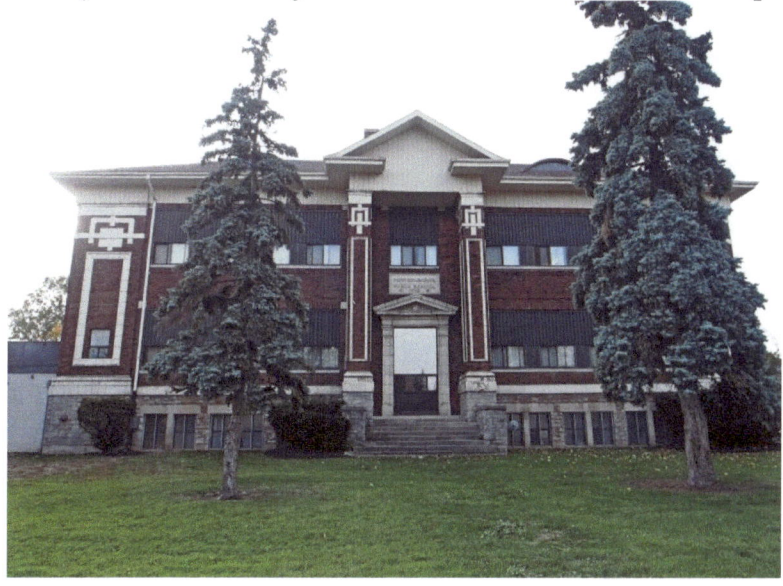

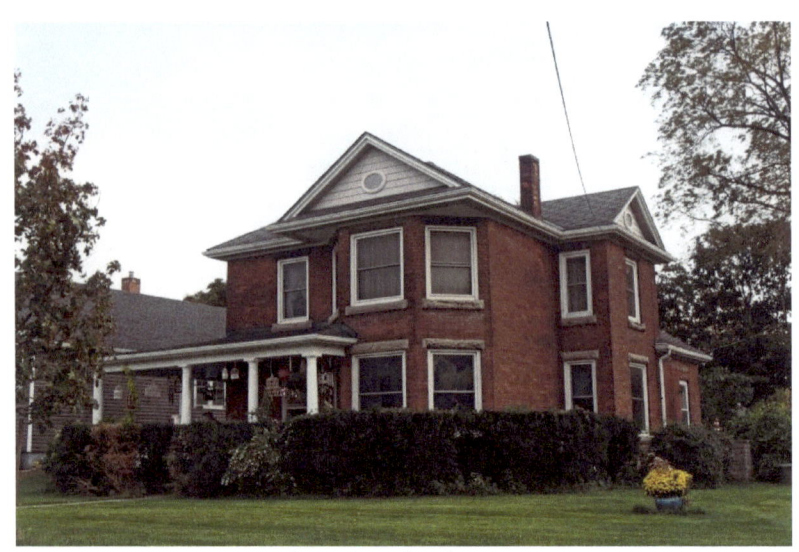

216 Steele Street

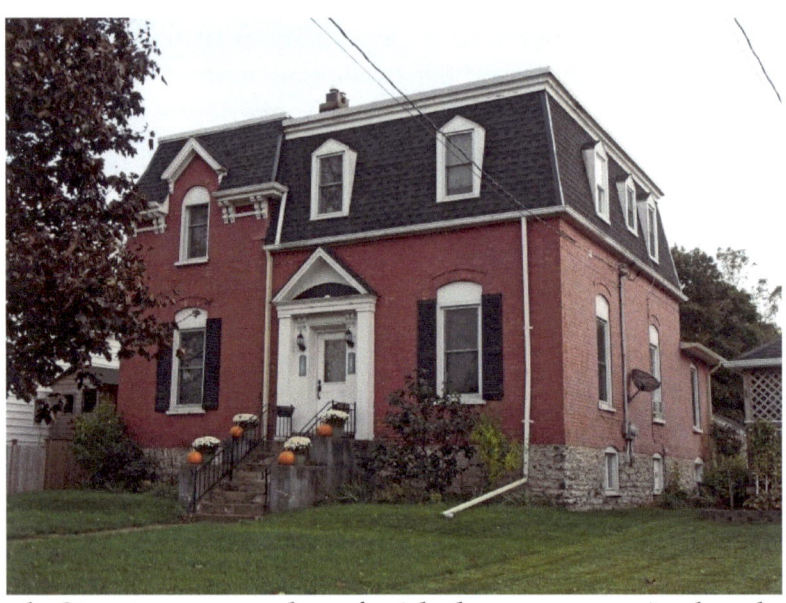

Steele Street – mansard roof with dormers, cornice brackets, cobblestone foundation

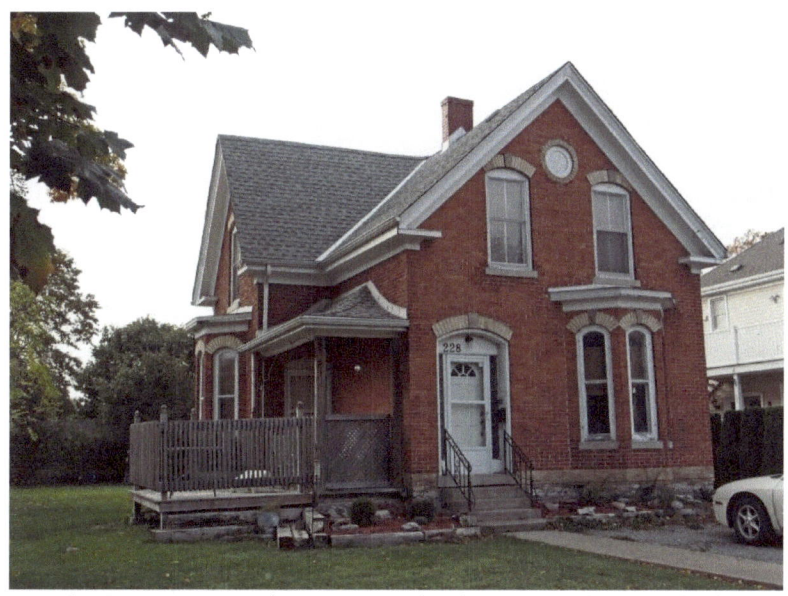

228 Steele Street – Gothic Revival – bay windows, dichromatic keystones and voussoirs, cornice return on gable

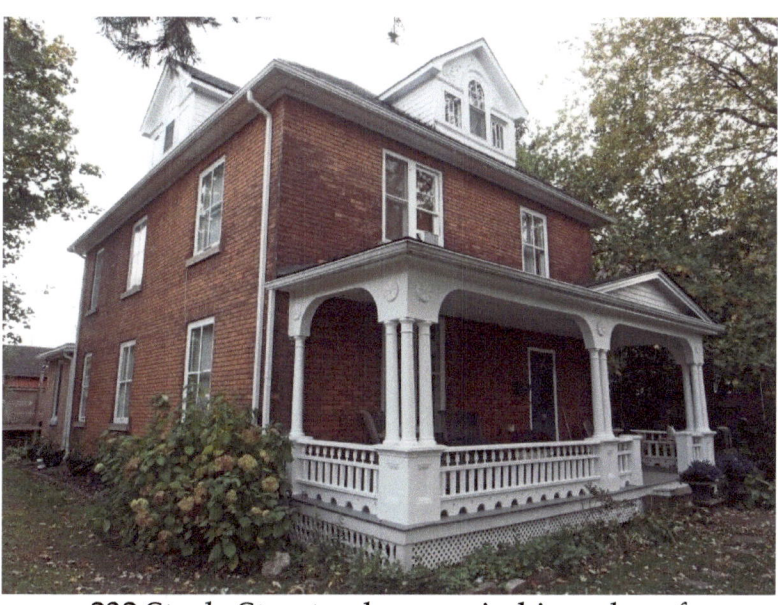

232 Steele Street – dormers in hipped roof

238 Steele Street – Gothic Revival – verge board trim on gables

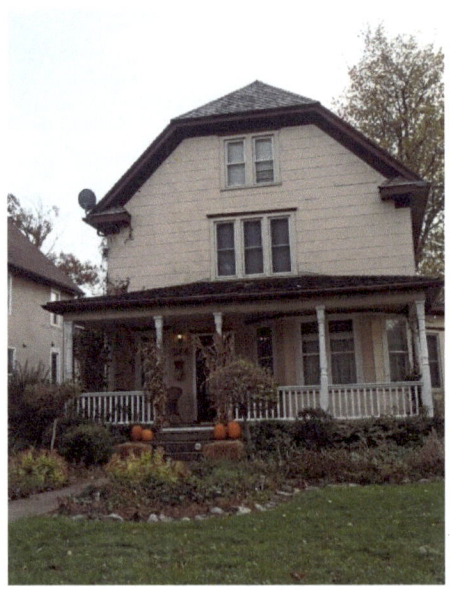

244 Steele Street – chipped gable with cornice return

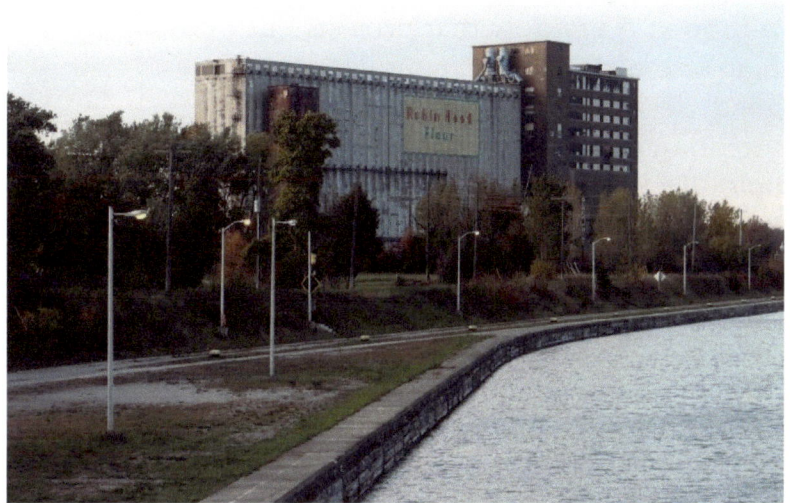

2 Sherwood Forest Lane – The old Robin Hood Flour Mill was one of two flour mills in Port Colborne (the other was the Maple Leaf Mill located north of the lighthouse at the entrance to the harbour). The elevator has a capacity of 2.25-million bushels of wheat.

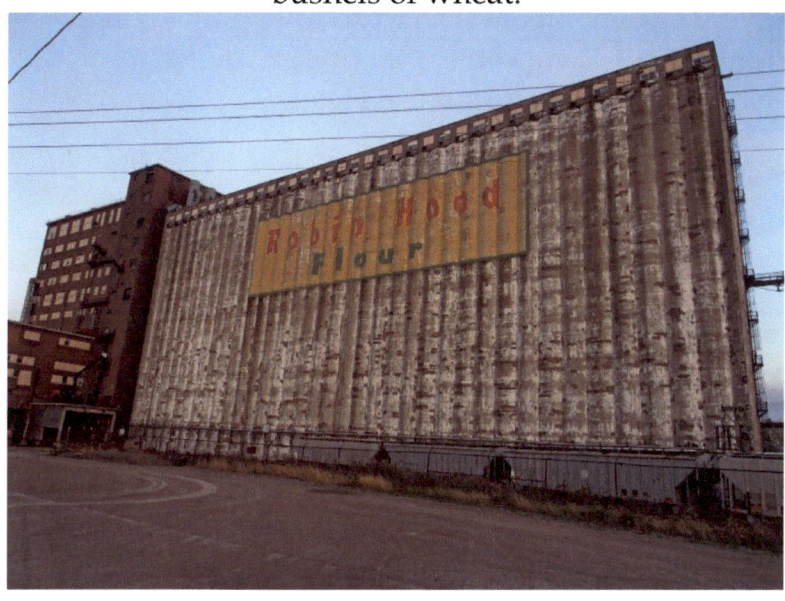

Architectural Terms

Bay Window: A window that projects out from a wall, in a semicircular, rectangular, or polygonal design. Used frequently in Gothic and Victorian designs. Example: 228 Steele Street, Page 59	
Brackets: a decorative or weight-bearing structural element which forms a right angle with one side against a wall and the other under a projecting surface such as an eave or roof. Example: Steele Street, Page 59	
Cobblestone architecture: Refers to the use of cobblestones embedded in mortar as a method for erecting walls on houses and commercial buildings. Example: Steele Street, Page 58	
Cornice Return: decorative element on the end of a gable. Example: 37 Main Street West, Page 18	
Dichromatic brickwork: the use of two colours of brick, tile or slate to decorate a façade. Example: 228 Steele Street, Page 59	
Dormer: (French for "sleep") a gable end window that pierces through the plane of a sloping roof surface to create usable space in the top floor or attic of a building by adding headroom. Example: 225 Main Street West, Page 9	

Frontispiece: a portion of the façade of a building, usually a centred doorway that is slightly raised from the rest of the building, usually has extensive ornamentation. Frontispieces are usually Classical in design with white columned porches. Example: 100 Sugarloaf Street, Page 38	
Gable: the triangular portion of a wall between the edges of a sloping roof. **Jacobean Gable:** the gable extends above the roofline. Example: 265 Main Street West, Page 7	
Gambrel Roof: a symmetrical two-sided roof with two slopes on each side; the upper slope is positioned at a shallow angle, while the lower slope is steep. A gambrel roof has vertical gable ends instead of being hipped at the four corners of the building. Example: 88 Steele Street, Page 52	
Hipped Roof: a roof where all sides slope downwards to the walls with no gables. Example: 27 Main Street West, Page 19	
Keystones and Voussoirs: a voussoir is a wedge-shaped element used in building an arch. A keystone is the central stone that locks all the stones into position, allowing the arch to bear weight. A keystone is often enlarged and embellished. Example: 228 Steele Street, Page 59	

Lancet Window: a tall, narrow window with a pointed arch at its top. Example: 375 Main Street West, Page 6	
Mansard Roof: This style was popularized by Francois Mansart (1598-1666), an accomplished architect of the French Baroque period and especially fashionable during the Second French Empire (1852-1870). This roof is almost flat on the top section, with two slopes on each of its sides with the lower slope at a steeper angle than the upper, and has dormer windows. Example: Steele Street, Page 58	
Palladian Window: a large window that is divided into three sections with the centre section larger than the two side sections and usually arched. Example: 27 Main Street West, Page 19	
Pediment: a triangular section above the door or portico, usually supported by columns. The inside of the triangle is called the tympanum. Example: 145 Main Street West, Page 12	
Pilaster: a slightly projecting column built into or applied to the face of a wall for additional structural support. Example: 91 Main Street West, Page 15	

Quoin: masonry blocks at the corner of a wall, often a decorative feature, usually larger or of a different colour than the rest of the wall. Example: 54 Sugarloaf Street, Page 35	
Tower: A circular, square, or octagonal vertical structure higher than the surrounding structure that is usually part of an existing building and is created either for extra defense or for a specific purpose such as a clock or a bell tower. Example: 65 Sugarloaf Street, Page 36	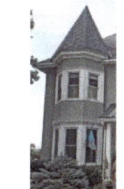
Verge board and Finial: also called bargeboards – hang from the projecting end of a roof and are often elaborately carved and ornamented. **Finial:** ornament added to the top of a gable, pinnacle, canopy or spire – a Gothic element. Example: 238 Steele Street, Page 60	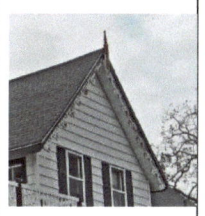

Building Styles

Classical Revival, 1820-1860 – This style was an analytical, scientific, and dogmatic revival based on intensive studies of Greek and Roman buildings, concerned with the application of Greek plans and proportions to civic buildings. Schools, libraries, government offices, and most other civic buildings were built in the Classical Revival style. The white columned porches of the Classical Revival domestic buildings are identified with the mansions of wealthy land owners in Canada. Example: 155 Main Street West, Page 11	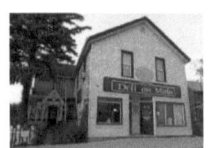
Edwardian, 1900-1930 – This style bridges the ornate and elaborate styles of the Victorian era and the simplified styles of the 20th century. Edwardian Classicism provided simple, balanced facades, simple rooflines, dormer windows, large front porches, and smooth brick surfaces. Voussoirs and keystones are used sparingly and are understated. Finials and cresting are absent. Cornice brackets and braces are block-like and openings have flat arches or plain stone lintels. Example: 214 Steele Street, Page 57	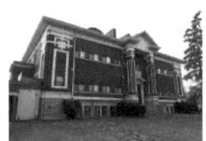

The **Farmhouse** is a country home style that highlights the simplicity of rural living. Comfort and function are the major themes that are associated with the style. The roof frequently flares out to cover the porch. The large porches were designed to help cool the interior of the home and also provide a shady spot for guests to gather and enjoy the outdoors. The architecture of a country home is minimally ornamental but very efficient with functional shutters, decorative porch railing, and dormer windows that increase interior light and living space. The exterior is typically faced with horizontal siding. Farmhouse floor plans are usually square or symmetrically shaped, sometimes with side wings. The interior has a large country kitchen and a cluster of bedrooms on the upper level. Farmhouses contain at least one fireplace and large family gathering areas designed for relaxation. The country home is casual, functional and comfortable. Well-crafted and sturdy, farmhouses are generally built to last and withstand for ages.
Example: 1271 Sherk Road, Page 31

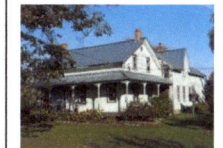

Georgian, before 1860 – This style began with the British King Georges in the 18th century. These buildings have balanced facades around a central door, medium-pitched gable roofs, and small paned windows.
Example: 1 Lake Street, Page 33

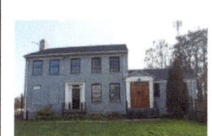

Gothic Revival, 1830-1890 – These decorative buildings have sharply-pitched gables with highly detailed verge boards, pointed-arch window openings, and dichromatic brickwork. It is a common style in Ontario. Example: 130 Main Street West, Page 13	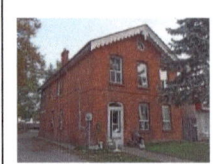
Italianate, 1850-1900 – A two story rectangular building with a mild hip roof, a projecting frontispiece, and generous eaves with ornate cornice brackets was the basis of the style; often there are large sash windows, quoins, ornate detailing on the windows, belvederes and wraparound verandahs. Example: 115 Main Street West, Page 14	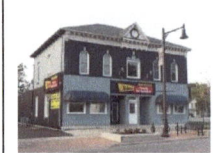
Neo-colonial architecture seeks to revive elements of architectural style of American colonial architecture of the period around the Revolutionary War which drew strongly from Georgian architecture of Great Britain. Architecture from the 18th and early 19th centuries in Ontario includes a wide assortment of detailing and ornament applied to a design centered around the fireplace and the source of water. Structures are typically two stories, have a symmetrical front facade with elaborate front doorways, often with decorative crown pediments, fanlights, and sidelights, symmetrical windows flanking the front entrance, often in pairs or threes, and columned porches. Example: 102 Steele Street, Page 53	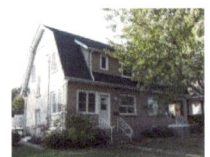

Palladian architecture is a European style derived from and inspired by the designs of the Venetian architect Andrea Palladio (1508–1580). Palladio's work was based on the symmetry, perspective and values of the formal classical temple architecture of the Ancient Greeks and Romans. From the 17th century Palladio's interpretation of this classical architecture was adapted as the style known as Palladianism. It continued to develop until the end of the 18th century. Example: 76 Main Street West, Page 16	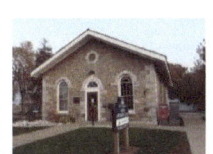
Romanesque Revival, 1880-1910 – This style hearkens back to medieval architecture of the 11th and 12th centuries with a heavy appearance, blocky towers and rounded arches. Example: 1001 Firelane No. 1, Page 27	
Tudor Revival – exposed timbers with stucco infill, multi-paned windows. Example: 48 Sugarloaf Street, Page 35	
Vernacular/Traditional Mode 1638 - 1950 Influenced but not defined by a particular style, vernacular buildings are made from easily available materials and exhibit local design characteristics. Example: 178 Steele Street, Page 56	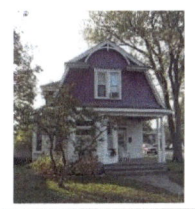

www.ingramcontent.com/pod-product-compliance
Lightning Source LLC
Chambersburg PA
CBHW041106180526
45172CB00001B/124